IMAGES
of America

# WAYLAND

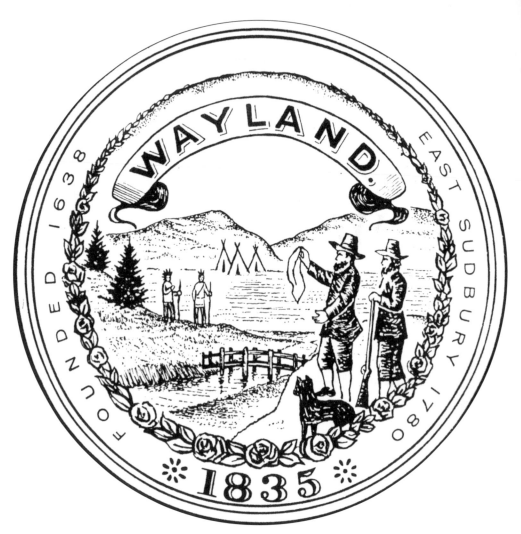

Every Massachusetts community is required by law to have a town seal, for use on official documents, signs, vehicles, and badges. Wayland's town seal was designed by Sylvester Reeves, a Wayland resident, and adopted in 1874. It is a romantic image of the founding of Wayland in the late 1630s. Two Puritan settlers and a dog are standing on the east side of the Sudbury River, signaling with a white cloth their friendship to two Native Americans on the opposite shore. A simple bridge over the river replicates the "Indian Bridge" mentioned in early colonial records. The tepees in the distance are Reeves's conception of the Native American shelters, drawn, perhaps, from his knowledge of the American West. At the time of this imaginary event, the whole area was known as Sudbury. When the settlement was divided into two parishes in 1780, the western parish retained the original name, while the one to the east became East Sudbury. Later, in 1835, its name was changed to Wayland.

IMAGES
*of America*

# WAYLAND

George Lewis and the Wayland Historical Society

Copyright © 2000 by George Lewis and the Wayland Historical Society.
ISBN 0-7385-0441-6

First printed in 2000.

Published by Arcadia Publishing,
an imprint of Tempus Publishing, Inc.
2 Cumberland Street
Charleston, SC 29401

Printed in Great Britain.

Library of Congress Catalog Card Number: 00-104068

For all general information contact Arcadia Publishing at:
Telephone 843-853-2070
Fax 843-853-0044
E-Mail sales@arcadiapublishing.com

For customer service and orders:
Toll-Free 1-888-313-2665

Visit us on the internet at http://www.arcadiapublishing.com

*On the cover:* The photograph on the cover was taken in 1915 by Alfred Wayland Cutting during the centennial celebration of the building of the First Parish Meetinghouse. The choir of the First Parish is dressed in clothing representative of that worn 100 years earlier.

# CONTENTS

Acknowledgments     6

Introduction     7

1.   Wayland Center     9

2.   Cochituate Village     23

3.   Getting around Town     35

4.   Getting to Know You     51

5.   Seeking Shelter     69

6.   Improving Spirit and Mind     79

7.   Making a Living     93

8.   Leisure Time     105

9.   Local Catastrophes     113

10.   Resting in Peace     123

# ACKNOWLEDGMENTS

The creation of this book was the joint effort of many people, all dedicated to informing the public about the history of this small town. I want to thank the Board of Managers of the Wayland Historical Society for entrusting this responsibility to me, involving, as it does, the safeguarding of one of the society's most popular and precious treasures, its collection of historical photographs. Joanne Davis welcomed me to the society's research facilities, made space available to me, and generally supported me at every stage of my work. Amelia Entin guided me through the organization of the photographic files and worked side by side with me in the selection of illustrations and the preparation of captions. Her experience in putting together the society's annual calendar was invaluable. Jane Mansfield and Mary Trageser often pitched in to find that elusive photograph. President Dick Hoyt used his background in teaching and writing to give my introduction a thoughtful and professional critique. Curator Emerita Jo Goeselt, who has an extraordinary knowledge of Wayland history, was always available to answer my questions.

Many Wayland residents helped me with information about the history of Cochituate, a part of Wayland with which I was less familiar. I am especially grateful to David Allen, former president of the Wayland Historical Society, for his insights and observations. Help also came from Elmer Bigwood, John McEnroy, John C. Bryant, Paul Kohler, Cliff Wedlock, Bruce Morrell, Marion Lever, Ben Johnson, Andy Moore, and the Sandy Burr Country Club.

The Wayland town clerk, Judy St. Croix, and the Wayland Board of Selectmen granted me permission to use the Wayland town seal as a historical artifact and illustration. At my meeting with them, it was decided to review the seal for accuracy and readability.

Several works on Wayland history helped me to interpret and describe the photographs that I had selected. Principal among these was Helen Fitch Emery's seminal work *The Puritan Village Evolves*. Emery wrote an eminently readable book, while skillfully managing to weave into her text those many important names, dates, and locations that I needed to make the captions accurate and precise. Her sections about Cochituate are exceptionally detailed. I also referred frequently to Alfred Sereno Hudson's *The Annals of Sudbury, Wayland, and Maynard* for factual information, especially from James Sumner Draper's "Location of Homesteads along Wayland's Highways." Barbara Robinson's *Wayland Historical Tours* provided useful names and dates. The Wayland Unitarian Church archives and published historical essays were helpful. Wayland is indeed fortunate to have such resources at hand.

# INTRODUCTION

It was grass, lots and lots of grass, that attracted the first settlers to Wayland—the same broad meadows that had drawn others several years earlier to Concord, only a few miles to the north. Wayland was originally a part of the Sudbury Plantation, one of the earliest English settlements inland, away from the coast of Massachusetts Bay. Sudbury was named for the town in England where its minister-to-be had been pastor. The river that flows through both Wayland and Concord and its adjoining floodplain offered farmland, already scarce in coastal towns to the east. About 150 men, women, and children moved into Wayland during 1638 and 1639, concentrating their first settlement in an area near present-day North Cemetery on Old Sudbury Road.

Long before the arrival of these Europeans, substantial numbers of Native Americans occupied the fields and forests along the river, which they called Musketaquid. Families lived in small groups in the semisedentary lifestyle characteristic of the Nipmuk peoples of the region. By the time of Sudbury's settlement, the population of Native Americans had been greatly reduced by contagious diseases introduced by explorers, fishermen, and residents of the coast communities. Since the settlers had every intention of paying for the lands they were about to occupy, relations between them and the native peoples were quite congenial. Unfortunately, King Philip's War ended this period of peaceful coexistence.

The General Court, the governing body of the Massachusetts Bay Colony, had granted the colonists 25 square miles as their legal territory. About one-third of this land was east of what the settlers called the Great River, and two-thirds was to the west. Most of the newcomers were farmers, but there were also carpenters, weavers, tailors, brewers, and, as required by law, ministers. They were skilled in measuring and marking field boundaries and immediately began dividing the land among themselves. They then built their first shelters, erected a small meetinghouse, set up a gristmill and a sawmill, and, most importantly, built a primitive, wooden bridge across the river to the west side.

The first 100 years of this new settlement saw the spread of small farmsteads into every corner of the original grant. Houses and barns were built of wood, unlike such buildings back in England, where stone and brick had dominated local construction. The main goal of every family was self-sufficiency, based on the keeping of livestock and supplemented by small garden plots, an abundance of game and fish, and an almost unlimited supply of timber. By 1700, the settlement was enjoying a more sophisticated lifestyle. Houses were larger, with better accommodations. Roads and bridges were widened and strengthened. Some schooling was

provided, and the doctor joined the minister as an important town figure.

Nevertheless, in 1707, disgruntled west-side residents petitioned for their own church, citing the long distances that many had to travel for Sunday services and town meetings. A new meetinghouse was built in what is today Sudbury Center. Meanwhile, the General Court added more land area to the town along its southern boundary with Natick and Framingham, including most of present-day Cochituate. At the same time, the court ordered that the meetinghouse at the North Cemetery be moved south to the present junction of Routes 20, 27, and 126. Half a century later, Sudbury residents voted to separate the east and west parishes into independent towns. What is now Wayland was then given the new name of East Sudbury. Thus began the evolution of Wayland Center into the compact hamlet of houses, taverns, shops, and public buildings that now forms the core of Wayland's historic district. Due to a steady increase in the number and prosperity of Wayland farmers, this part of town became an important service and transportation center. The arrival of the Central Massachusetts Railroad in the early 1880s reinforced the dominant position of Wayland Center, as did the erection of a new town hall across from the depot shortly thereafter.

During much of the 18th century and well into the 19th, the Cochituate area remained relatively unpopulated, characterized by widely scattered farms with closer contact with Natick than with Wayland Center. It was common practice at that time for farm families to assemble shoes at home from parts provided by outsiders. Before long, however, the development of the factory system and the invention of shoemaking machinery spurred local entrepreneurs to build large shoe factories in Cochituate Village.

The resulting demand for more laborers brought an influx of workers from elsewhere in Massachusetts and parts of Canada. The wildly successful shoe business soon propelled Cochituate ahead of Wayland Center as the focus of political power. Cochituate's newfangled rectilinear street pattern, its sidewalks, electric streetlights, trolley line, and ball field gave the village a surprising touch of urbanity. The new mill owners built elaborate Victorian residences along Main and Pond Streets. By the beginning of the 20th century, however, the shoe industry began a slow decline, and the last factory there closed in 1913.

Meanwhile, Wayland Center was experiencing new vitality, as Boston businessmen, lawyers, and engineers moved to the town and commuted to work on the railroad. Concurrently, a number of well-to-do Boston families sought out summer homes in the Wayland end of town, often buying and renovating local farmhouses. The contrast between blue-collar Cochituate and the Social Register of Wayland was sharpened as Wayland newcomers hired unemployed Cochituate residents as maids, chauffeurs, and groundskeepers.

The Great Depression of the 1930s put a sudden end to normal life in both ends of Wayland. Federal relief programs sustained many families and provided enough jobs in the public sector to yield substantial benefits to the town, including an expanded water-supply system and a new high school.

The five decades since the end of World War II have brought unparalleled changes throughout the town and have, fortuitously, drawn the once very different centers of the town together in a new sense of shared community. The arrival of more than 10,000 new residents, with the attendant building of new houses and roads and the growth of public services and retail shops, has given the town a pleasant suburban ambiance. At the same time, thoughtful planning and zoning have protected Wayland's semirural environment, thus retaining a sense of those grassy meadows that drew the first settlers many centuries ago.

# One

# WAYLAND CENTER

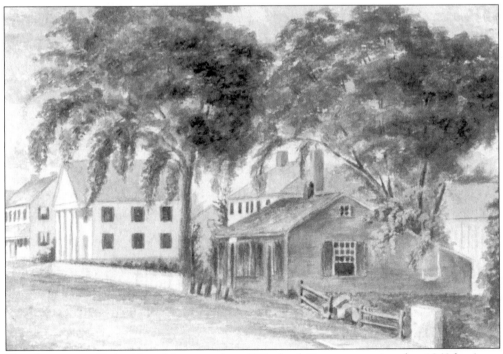

This diminutive (7- by 10-inch) watercolor of Wayland Center was painted c. 1860 by Anna Dudley from a window in her home at the junction of Old Sudbury and Concord Roads. It shows (from left to right) the George Smith House, the first town hall (Collins Market), the roof of the J.F. Heard-Lovell House, and the "Old Red Store." The box at the far right is the mechanism of the town scales. The store had incorporated the remains of the old Center School, and when it in turn had to be moved, it was attached to the nearby Lovell barn.

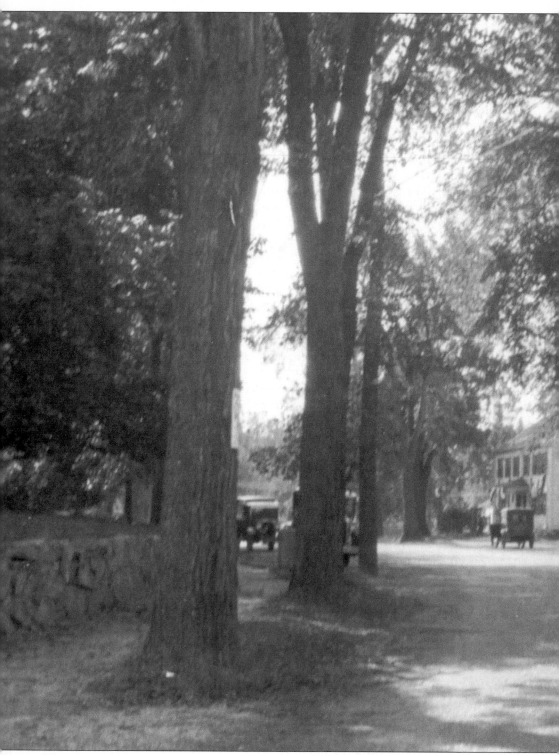

This photograph, taken by Wallace Folsom in 1930, is virtually the same scene painted by Anna Dudley. A small white post office now sits next to Collins Market. All the buildings are

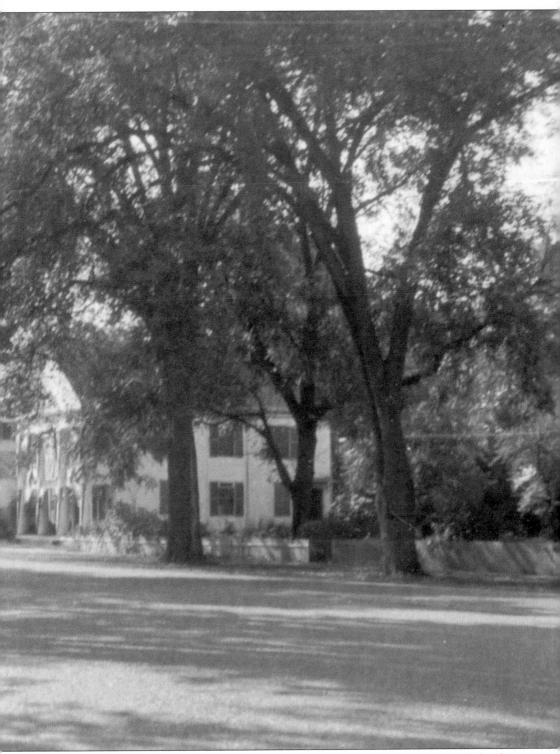

decked with bunting to commemorate Massachusetts's tercentenary year. The row of elms has grown, and their branches spread across Cochituate Road to shade the street.

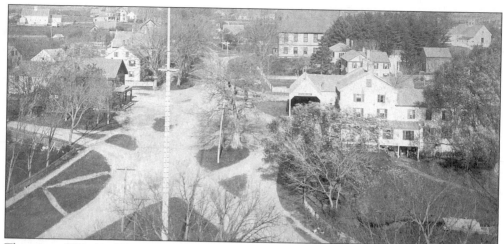

This view of Wayland Center was taken from the belfry of the Unitarian church, looking north toward the railroad (the warning sign of which is visible). Only about half of these buildings are still standing. All the dirt roads and paths have since been widened and realigned as the automobile has taken over the American road. The vertical white line is the town's flagpole. The Wayland Inn appears at the far right.

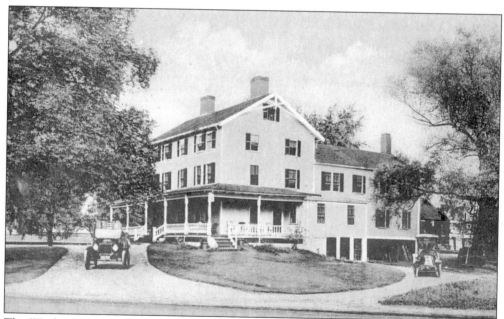

The Wayland Inn was built in 1771 as a tavern, it was long known as the Pequod House. It offered food, drink, and lodging to generations of travelers, townspeople, and their horses. Wayland's town pump and watering trough stood in front of the building. The inn and its barn were purchased in the 1920s and were torn down in 1928.

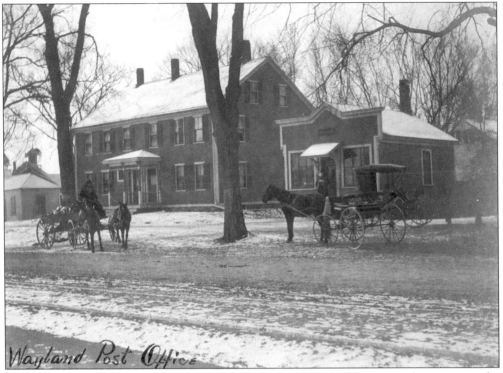

*Wayland Post Office*

This snowy scene shows three important Wayland Center buildings. At the center is the George Smith House, built in 1845 as a residence and store with Wayland's first post office. The tiny structure at the right was built in the 1890s as the first "official" post office building. Barely visible at the far left is the Mellen Law Office, built in 1826. All three buildings still stand.

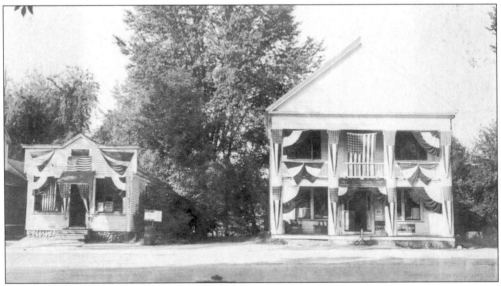

The first post office reappears alongside the classic Greek Revival structure most recently known as Collins Market. Built in 1841 by Deacon James Draper, it was Wayland's first town hall. Over the next 160 years, it also served as an academy, a library, a grocery store, and most recently, a modern office building.

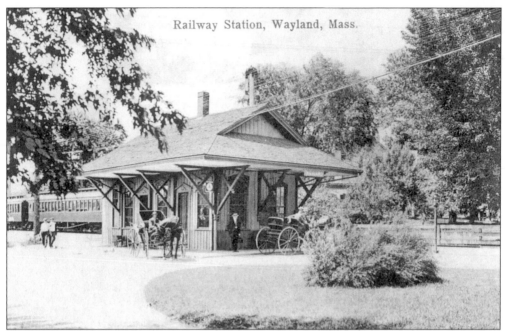

Railway Station, Wayland, Mass.

Wayland's only railroad station anchors the northern end of Wayland's downtown. Built in 1881 in an unusual stick-style design, it initially served the Central Massachusetts Railroad. After the line was abandoned in 1980, the station was purchased by the Town and is now leased to a nonprofit organization to serve as a gift shop featuring the work of local artists.

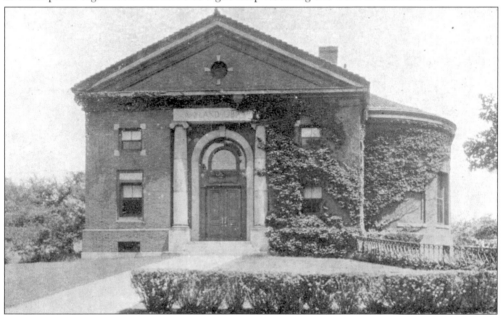

The Wayland Public Library opened in this Mediterranean-style building in 1900, built with money and land bequeathed by Warren G. Roby, a next-door neighbor. This is the library's third location, having once been housed in the Collins Market building and later in the 1878 town hall. An act that was introduced by Wayland's Rev. John Burt Wight (and passed by the Massachusetts legislature) allowed the use of tax money to support public libraries.

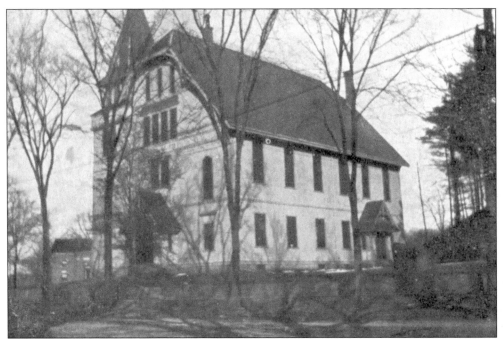

Across from the 1841 town hall is the 1878 town hall, built in an era when public buildings were receiving more attention. On the ground floor were town offices and a library room. Upstairs was a large, high-ceilinged room used for town meetings, flower shows, country dancing, and badminton. The fire department had a garage and storage area at the rear. The building was torn down in 1957.

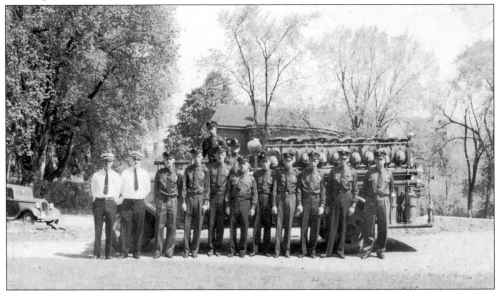

Members of the Wayland Fire Department of the 1930s line up with their truck for a photograph. These were all "call men," with officers designated as "engineers." Firemen were paid at an hourly rate for responding to an alarm. Fires in nearby woods were frequent. Barn fires were not uncommon and usually brought out a good crowd, as did the occasional house fire. A horn on the town hall tower signaled the location of every alarm.

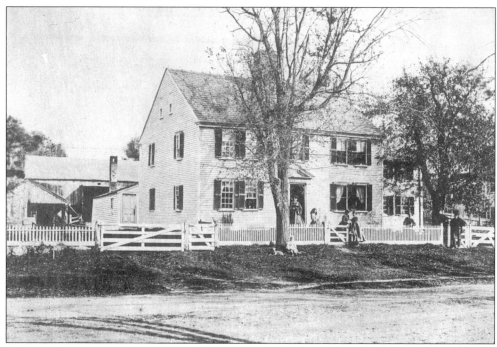

The Grout-Heard House is the oldest building in Wayland Center. Like many New England residences, it started out as two rooms in the 1740s, and rooms, ells, sheds, and bay windows were added over time. The house was long associated with the Grouts (millers and surveyors) and the Heards (storekeepers and farmers). It was moved a short distance away in 1878 to make room for the town hall.

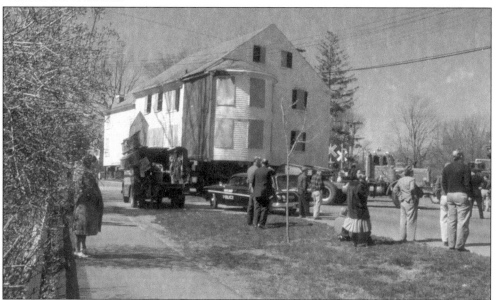

This photograph shows the Grout-Heard House crossing the railroad tracks as it makes its way home after exile on Old Sudbury Road. The Raytheon Company had acquired it with a land purchase for a new laboratory building and made it a gift to the Wayland Historical Society. The society maintains several period rooms, as well as supporting an active research program.

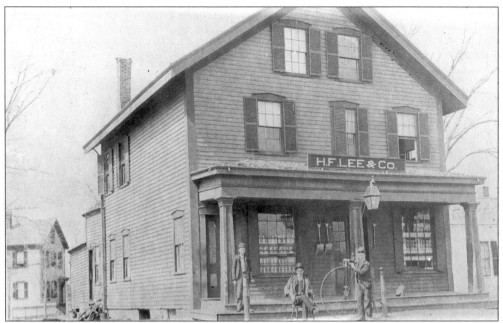

The triangle of land in Wayland Center bounded by Cochituate Road, the Post Road, and Pelham Island Road was originally occupied by three buildings. The largest of these was H.F. Lee's, a typical New England general store, selling almost everything a resident might need. The wide veranda encouraged a stop for news or gossip. The store was torn down in the 1920s.

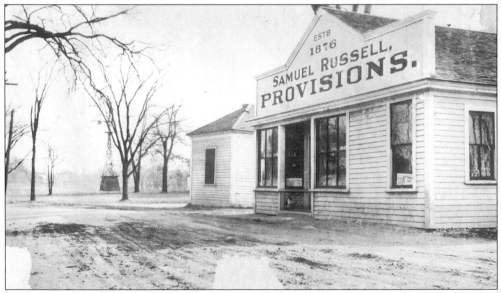

The Russell family has a long tradition in Wayland agricultural and business life. Sam Russell built his provisions store on the triangle facing Pelham Island Road in the late 1800s. The Western-style facade was popular at the time. In the background, across Cochituate Road, is an open field and a windmill where the Pequod House had once been located.

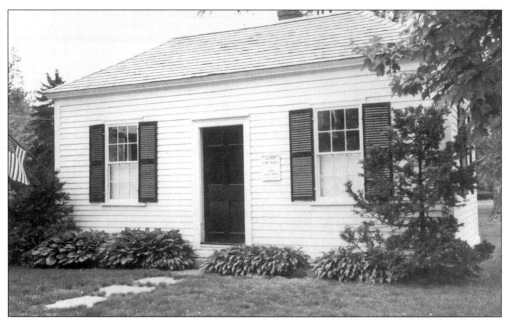

The third building on the triangle—and the only one still standing—is Judge Edward Mellen's law office, built in 1826 by Samuel Mann. It has two rooms and a wood stove, but no plumbing. Fortunately, Mann lived across the street. Mellen occupied the office for many years as he established himself as one of Wayland's more distinguished residents.

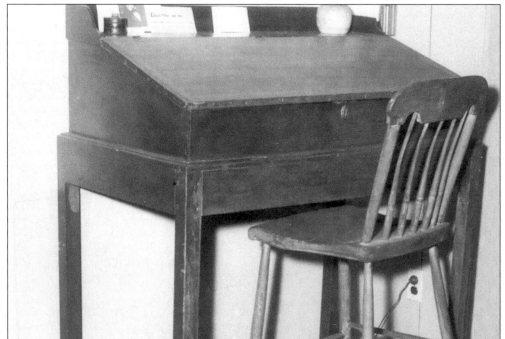

The country law office is now a rarity on the New England scene; so is the lawyer's desk, designed and built for standing rather than sitting. This desk comes from Judge Edward Mellen's office and now resides in the Stone Room at the Grout-Heard House. The long legs bring the writing surface up to 40 inches above the floor.

In the early 1800s, Wayland entered a period of building one-room schoolhouses in every part of the town. This house is the last reminder of that era and sits on Pelham Island Road. Built of brick, the school opened in 1808. Eventually, the Town sold the building to a family that converted it to a residence, which it remained for nearly a century.

The Bigwood family operated a successful taxi business out of the converted 1808 schoolhouse for many years. After WWII, the demand for commercial space in Wayland led to the sale of the Bigwood House and its remodeling into office space. The brick exterior and interior were largely preserved, and a wing was added. The first tenants were a bank and a popular hair salon.

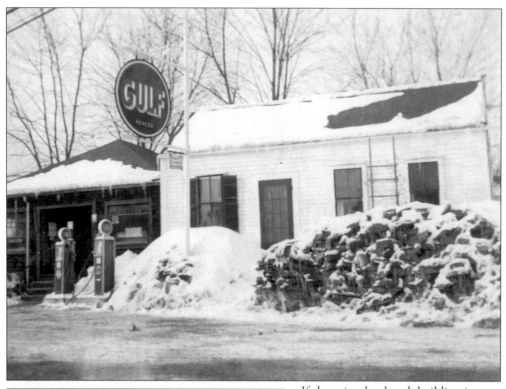

If there is a landmark building in Wayland, it is Benson's store, known to generations from all walks of life. Opened in the early 1900s by Charles Benson, it was the forerunner of today's convenience store—newspapers, limited groceries, tobacco, and, for some years, gasoline. Over time, the focus has shifted to coffee and light meals for a faithful clientele.

For several decades, Benson's was called Tom Barr's after Tom Barr came to Wayland and married Myrtice Benson. The Barrs and their children lived in the white house shown in the photograph at the top of this page. Tom Barr met every departing commuter train at the station with piles of newspapers. The name Benson's is now unchallenged. Yes, it was their anniversary.

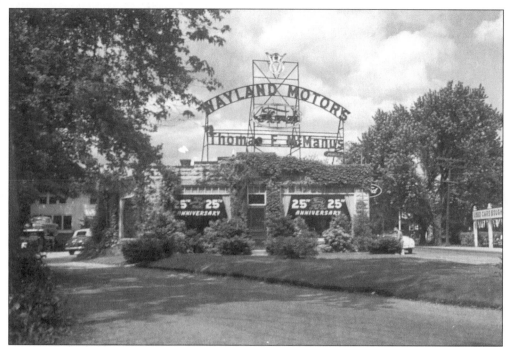

In 1915, Thomas McManus, son of a Wayland blacksmith, opened an Overland auto dealership on the Post Road West. Henry Ford later persuaded him to switch to Ford, and a very successful business, known as Wayland Motors, was born. A shiny new Ford was always kept on display at the apex of the lot. When the business closed in 1979, it was sold to the Town and demolished. It was replaced by a new public park, called Blacksmith Green.

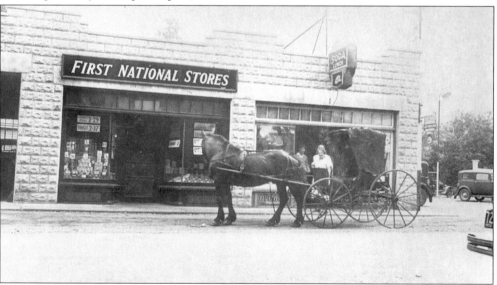

At the west end of his showroom and garage, Thomas McManus provided space for two small stores, a First National grocery and a bus stop–spa–convenience store. The First National did not carry meat, but it was still very popular, largely due to the cheery, helpful personality of its manager, Lewis "Looie" Graves. By the time of this photograph, horse-drawn buggies were a rarity.

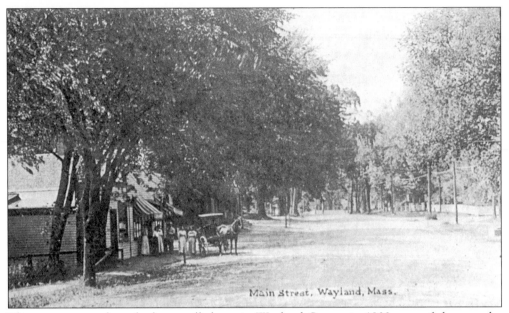

Main Street, Wayland, Mass.

There were a number of other small shops in Wayland Center in 1900, two of them at the southwest corner of the Post Road–Cochituate Road intersection. One of these was Sarah Russell's tiny thread and needle, candy and ice-cream shop—the place with the awnings. A barbershop was located next-door. Both were later purchased and razed to provide open space.

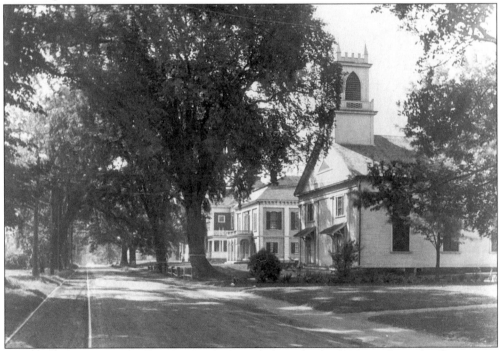

From that same intersection we can look south on Cochituate Road to the Trinitarian Congregational Church, the Odd Fellows Hall, and the Center School, all facing the street and the trolley tracks to Cochituate. Only the Odd Fellows building remains. The road appears to be still unpaved. (Photograph by A.W. Cutting.)

# Two
# COCHITUATE VILLAGE

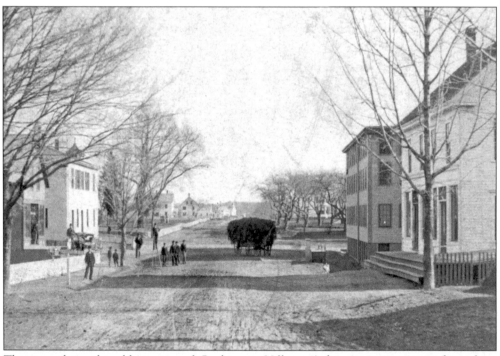

This is perhaps the oldest view of Cochituate Village. A hay wagon is proceeding along Commonwealth Road near its intersection with Main Street. The light-colored building on the left eventually housed Benjamin Johnson's drugstore and the Cochituate Post Office. Commonwealth Road was first called Lake Avenue and then Pond Street. Main Street started out as Centre Street. The general area was known as Bentville, after the dominant family in the neighborhood.

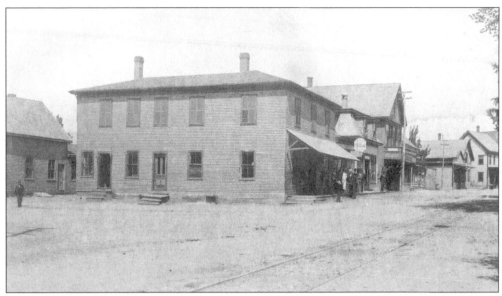

This solid-looking building with the large awning is the same one that appears on the left side of the previous photograph. It sat on the northwest corner of the busiest intersection in Cochituate. Known at one point as the Bryant Block, it had several owners over the years. The row of stores at the far right remained unchanged until after WWII. The trolley tracks are entering Cochituate from nearby Natick.

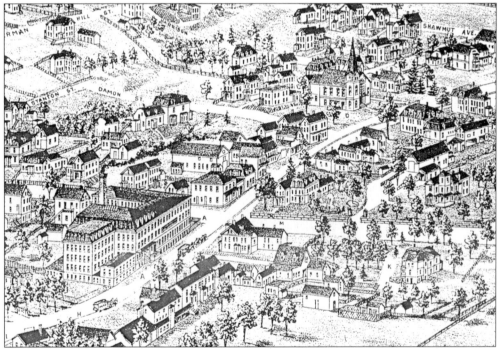

Directly across Commonwealth Road from the Bryant Block was the largest building in Wayland, the William & J.M. Bent Shoe Factory. This bird's-eye view of Cochituate, a map drawn in 1887, shows the factory at the center of this section near the letter A. The Bryant Block with its awning is just to the right of the factory. Note the two horse-drawn trolley cars.

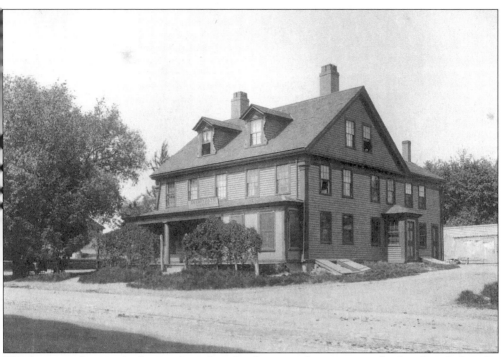

This large residence, which served as a boardinghouse at the time, can also be identified in the bird's-eye view on the opposite page, directly across Main Street from the factory. This was the ancestral home of the Bents, built before 1775 by Lt. William Bent, a Revolutionary War veteran. James Madison Bent took up shoemaking in the 1830s and went on to introduce the factory system to Cochituate.

The fourth corner of this important intersection was occupied by James M. Bent's house, a very large and elaborate mansion typical of those built by the principal shoe entrepreneurs of the town. The extensive yard was centered around a grandiose fountain. The house was purchased later and torn down to make room for the showroom and garage of Cochituate Motors.

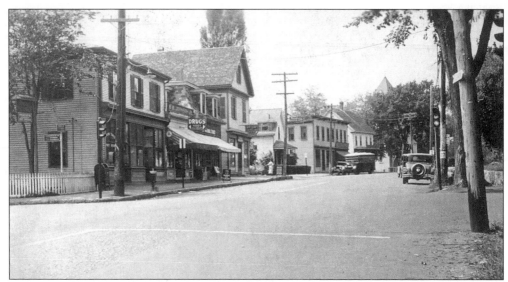

Main Street was the spine of Cochituate's commercial district. Along the left (west) side was the Cochituate Post Office, Johnson's Pharmacy, an A & P grocery, Gerald's News Store, and several small shops in Mrs. Loker's building. On the opposite side was a similar row of stores, catering to Cochituate shoppers' every need, except for big-ticket items.

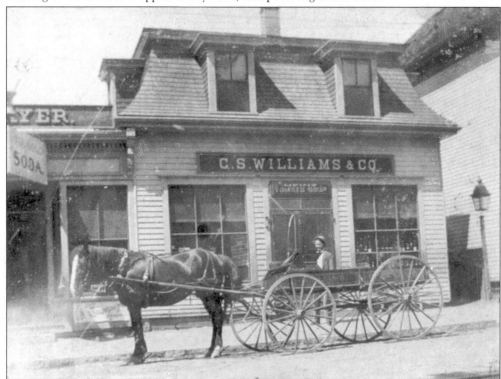

With careful inspection, you can identify this store just beyond the awnings visible in the previous photograph. It was Clarence S. Williams's grocery store, and that may well be C.S. himself standing beside his wagon on Main Street. The mansard roof was extremely popular in Cochituate, and many builders adopted this style throughout the town.

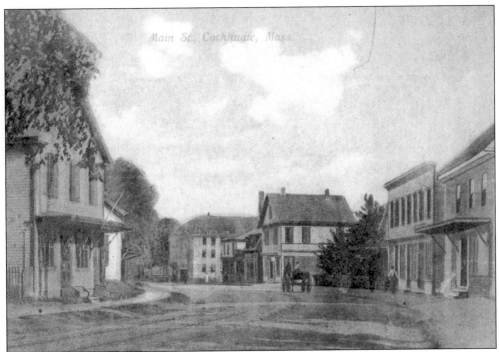

This is the same stretch of Main Street, but viewed from the north, looking toward Natick. The buildings at the far left housed a number of small businesses and shops, including a tinsmith's, which stood where the Hannah Williams Playground is today.

During the second half of the 19th century, Cochituate Village spread out across the level fields in all directions except south. Streets were laid out, and houses were built for workers. This photograph, taken from the 1873 school, shows Main Street at the left and the Methodist church at the far right. In between, Harrison Street and Shawmut Avenue are filling up with dwellings.

Arthur E. Peck was working for Mrs. Remick's grocery store when this photograph was taken. Later, he and Romeo Davieau purchased the business and set up shop as Peck & Davieau. The horse and wagon came with the sale. It was not uncommon for such stores to give credit and make home deliveries throughout the village.

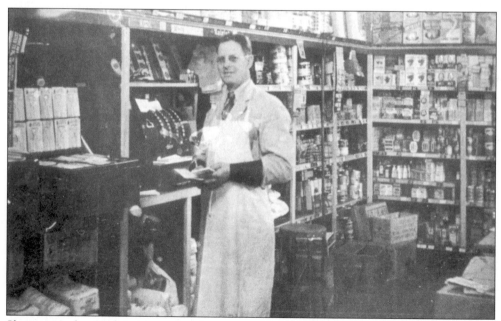

Shown is Arthur Peck in his store at the corner of Damon and Main Streets. Peck and Davieau pioneered in several merchandizing developments, including the introduction of frozen foods.

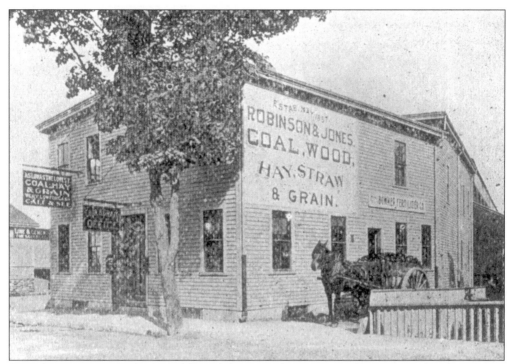

Some businesses in Cochituate Village did not need Main Street locations. Robinson & Jones required only a large storage building and a small office to provide substantial quantities of hay, grain, coal, lumber, and other building materials. "As Low as the Lowest" was their motto. Theirs was the first building on Damon Street, across from the Methodist church.

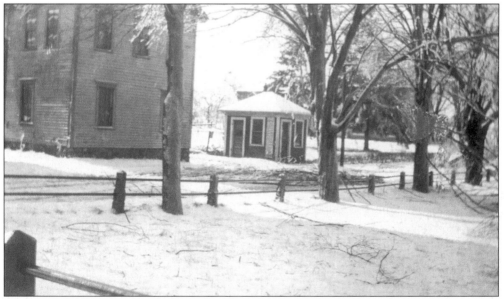

Farther down Damon Street, this dollhouse-sized structure was the Robinson & Jones coal office. Due to the lack of a railroad connection, all bulk commodities such as coal had to be brought to Cochituate by wagon or truck. The small building was later taken over as an office by George C. Lewis, a real estate agent. It was certainly Cochituate's smallest commercial space.

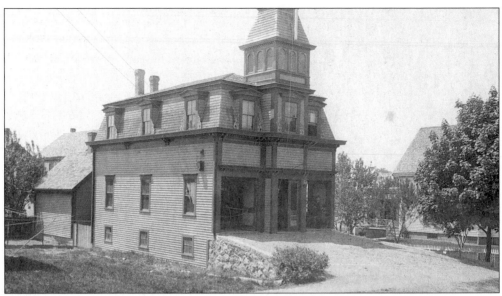

Built on Main Street in 1882 and later moved to Harrison Street, the Engine House was one of Cochituate's signature landmarks. Not only did it serve the fire department, but it was also a polling place and provided a meeting space for many local organizations. Mill owners, in particular, encouraged the establishment of a skilled and well-equipped firefighting force.

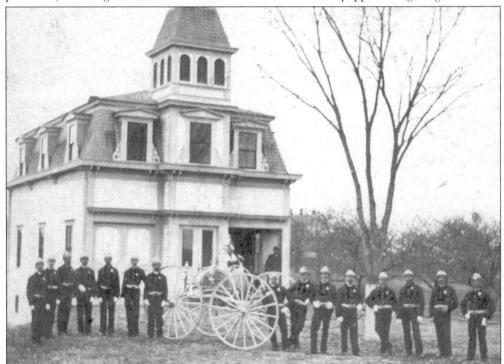

The 19th-century fire department was divided into two units: the James M. Bent Hose Company, shown here, and the Charles H. Boodey Hook & Ladder Company. Boodey was a popular physician who enjoyed supporting public enterprises. The two companies frequently ran speed trials based upon mock events simulating all types of fires.

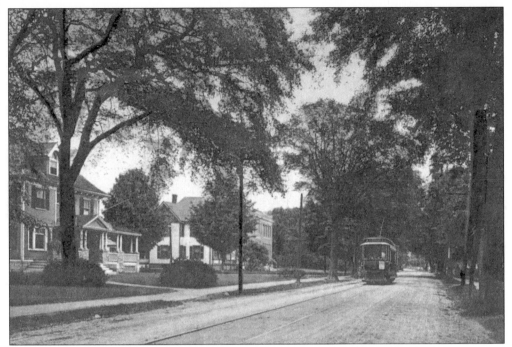

This leafy section of Cochituate, halfway between Bent's Corner (junction of Main Street and Commonwealth Road) and Lyon's Corner (junction of Main and West Plain Streets), was home to Cochituate's growing upper-middle class. A trolley on its way to Natick is approaching from the carbarn at Lyon's Corner.

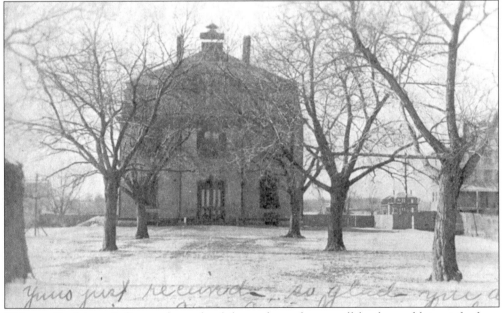

This was Cochituate's first modern school, located on a large, well-landscaped lot not far from today's basketball courts. It cost about $15,000 and was completed in 1873. Although designed for all 12 grades and referred to as an academy, the school was soon filled to capacity with elementary-grade youngsters. Alternate-year town meetings were held in this building.

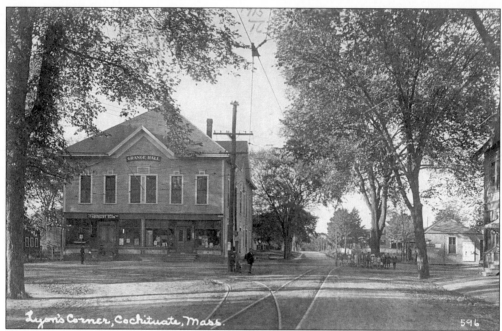

This imposing structure was built at Lyon's Corner in 1888 by the labor unions that had successfully organized the shoe workers. It was called the Knights of Labor Hall. Part of the ground floor was rented as shops, including a grocery and a meat store. Upstairs was a very large meeting hall for union activities, as well as for town meetings and other public events. Later rented to the Grange and then to the American Legion Post, the building burned down in 1925.

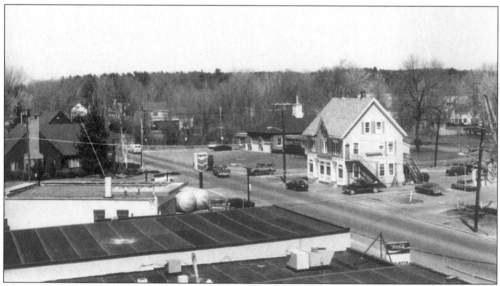

This is a more recent view of Lyon's Corner, taken from the roof of the 1910 grammar school. Albert B. Lyon and Otis T. Lyon had operated shoe- and box-manufacturing facilities nearby, and Albert Lyon had sold the land to the Town to build the 1873 school. In 1889, Noble Griffin bought the Lyon factory and the adjoining land, which had already become Cochituate's baseball field.

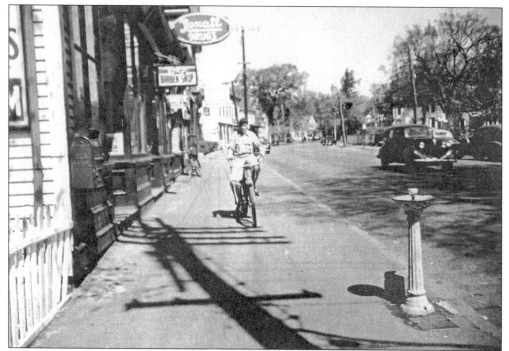

This photograph captures the spirit of Cochituate Village just before WWII—busy stores, traffic, sidewalks, penny candy at Gerald's, the old bubbler, and a carefree life on your bike.

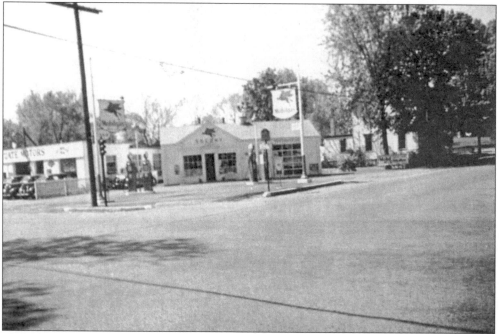

This 1930s view shows the southwest corner of the intersection of Commonwealth Road and Main Street, once occupied by the huge Bent shoe factory. Cochituate Motors and the Mobil gas station are indicative of the ever-changing Cochituate landscape. Both facilities have been replaced by a small contemporary retail complex.

A post office was established in Cochituate in 1846, at the time when the name of the village changed from Bentville to Cochituate. Over time, the post office migrated from building to building until it settled down in the Bryant Block behind Johnson's drugstore, where it stayed until the 1980s. The entire corner was cleared and a new post office was erected in 1986. (Photograph by Dickie Perelli.)

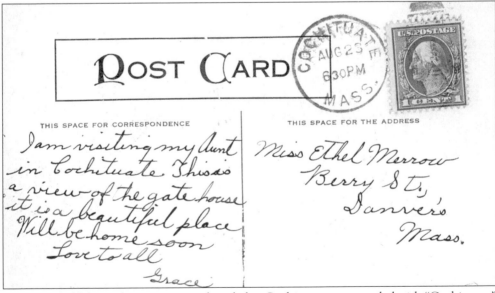

In the good old days, a letter or postcard mailed in Cochituate was canceled with "Cochituate." This is no longer the case. As a matter of fact, you are lucky if it says "Wayland" and not "Worcester."

# *Three*
# GETTING AROUND TOWN

This smart-looking buggy has stopped in front of the house at 110 Plain Road, built by James Sumner Draper in 1834. Draper's father, Deacon James Draper, had built the family homestead next-door in 1818. The neighborhood was not yet known as Tower Hill, nor had any of James Sumner's children built their several substantial summer residences across the street.

Molly Temple Wentzel drove one of Wayland's early school buses, which were sometimes called "barges." Her family lived in the Brintnal-Loker House on Loker Street, seen in the background. Her route led from Loker Street down Rice Road to the Boston Post Road and then along the Post Road to the high school, located at that time in the Independent Order of Odd Fellows building on Cochituate Road.

As late as the 1930s, Alfred Wayland Cutting continued driving his horse, Roger, and his victoria into Wayland Center. Cutting enjoyed holding up traffic with his favored conveyance and would tie up at one of the granite hitching posts along Cochituate Road. This photograph shows him entertaining Beth Goodell and Sally Upton, who are out roller-skating. (Photograph by Wallace Folsom.)

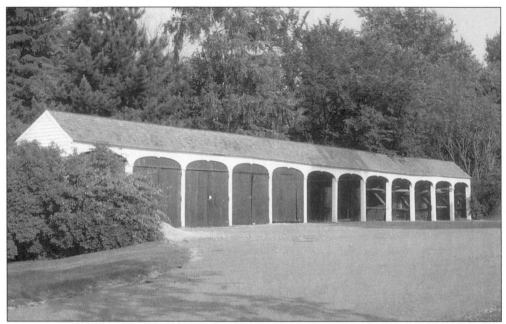

This row of carriage sheds was built on the east side of the Unitarian church. Individual stalls could be "bought" by members of the congregation. The horse and as much of the carriage as possible would be tethered at the rear of the shed during services. A similar row on the south side was removed. The Trinitarian Congregational Church had a similar arrangement of sheds.

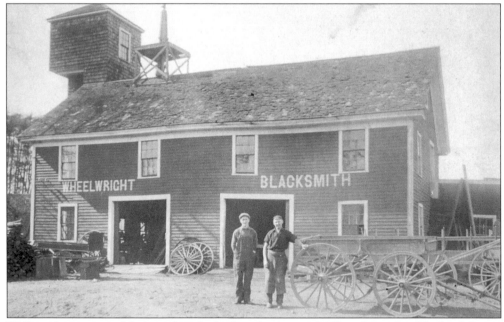

William Stearns ran a blacksmith and wheelwright shop on Millbrook Road in Wayland Center until well into the 20th century. These two services were essential to a horse-oriented culture and the transportation system that resulted from it. The water tower in the background was another familiar feature in a town without a public water supply.

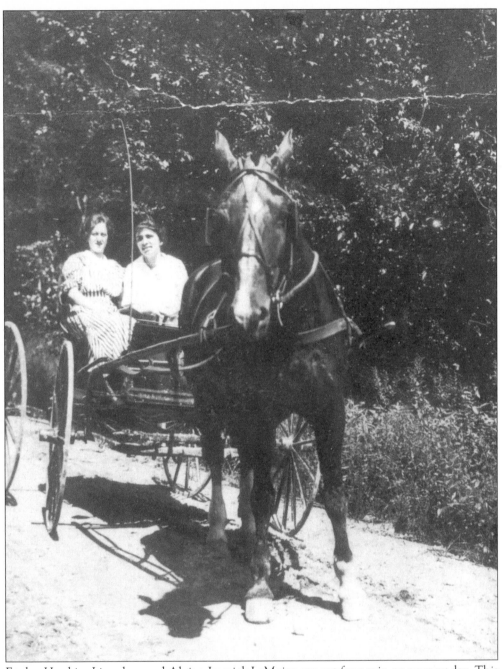

Evelyn Hawkins Linnehan and Alvina Immick LeMoine are out for a spin on a sunny day. This type of buggy was one of the most popular carriages—once you got up onto the seat.

This is the place in north-central Wayland where Mill Brook crosses Claypit Hill Road. There was no bridge across the brook, so carriages, wagons, and horses went right through the water. This was probably the last ford in town. The vehicles benefited because the spokes were briefly soaked to tighten them against the rim and the axle. Also, the horses got a drink. (Photograph by A.W. Cutting.)

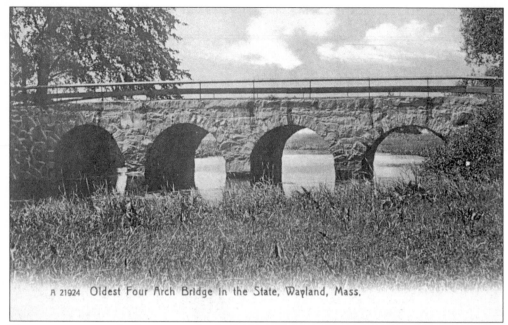

A 21924 Oldest Four Arch Bridge In the State, Wayland, Mass.

There were once six bridges across the Sudbury River in Wayland. The four-arch stone Town Bridge shown here appears to be very old, but it is actually only the latest of many earlier bridges at this site, the first having been built of wood in 1643. This particular bridge was built in 1848 and given a major overhaul toward the end of the 19th century.

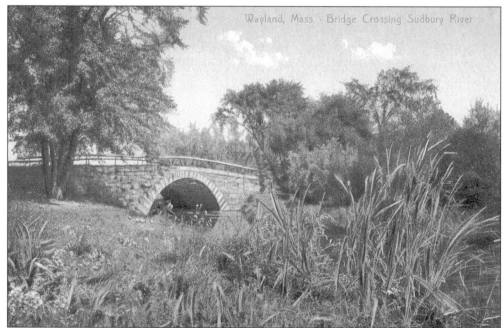

Wayland, Mass. - Bridge Crossing Sudbury River

The Sudbury River does an exaggerated loop near the Town Bridge. During the 18th century, a ditch was cut across the loop, which created a need for a second bridge on this causeway. This handsome single-arch stone bridge, called the Canal Bridge, was demolished when Route 27 was realigned and a modern bridge was built. The Town Bridge was spared.

40

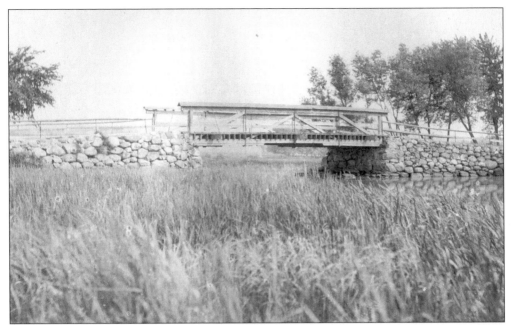

The Farm Bridge enabled the residents of Pelham Island to travel back and forth to Wayland Center from their farms. There may well have been a ford here at an earlier time, since large quantities of stones lie under the present bridge at this site—a technique for hardening a muddy bottom.

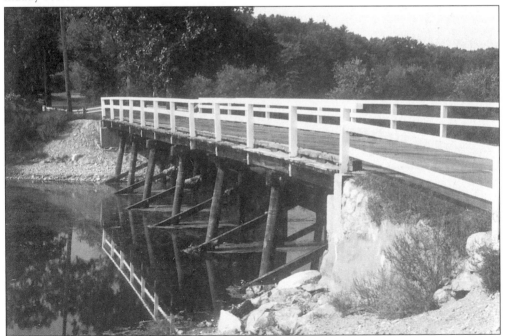

Sherman's Bridge was built to link two causeways extending from both the Sudbury and Wayland sides of the river. Farmers on one side often owned land on the other, and there was traffic to sawmills in Wayland and to Waltham and Boston by families in the Pantry section of Sudbury. The maintenance and repair of the bridge is the joint responsibility of the two towns.

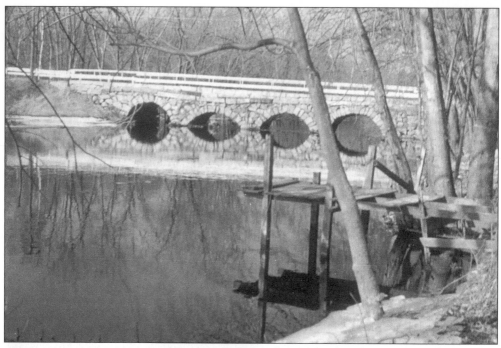

Stone's Bridge, shown here, is often miscalled Stone Bridge. This part of Wayland was dominated by the Stone family, hence the name. There were several wooden bridges here, until this four-arch stone bridge was built *c.* 1859. Col. Henry Knox crossed an earlier bridge here with his ox-drawn cannon train in 1776, bound for Boston and Dorchester Heights.

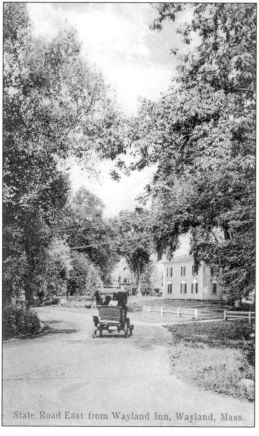

State Road East from Wayland Inn, Wayland, Mass.

The introduction of the automobile brought a whole new dimension to Wayland's transportation system. This post–World War I car is leaving Wayland Center and traveling east on the Post Road. The house on the right is "Kirkside," next to the Unitarian church.

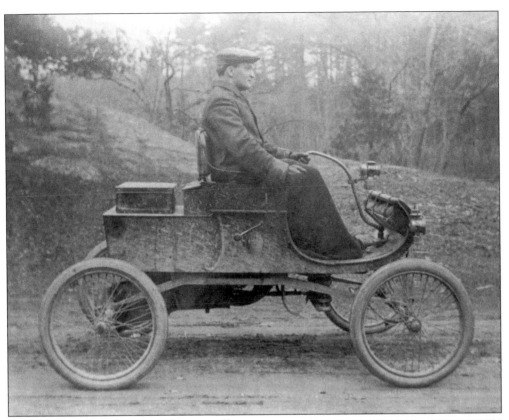

Frank Yeager of Cochituate is showing off his new car c. 1908. Yeager was one of the first in town to own an automobile, which he steered with a tiller in his left hand and a hand brake in his right.

Everett Bigwood grew up in the old brick schoolhouse on Pelham Island Road from which his family ran Wayland's first taxi service. As a teenager and young adult, he enjoyed nothing more than tinkering with cars like this one, which appears to be destined for racing.

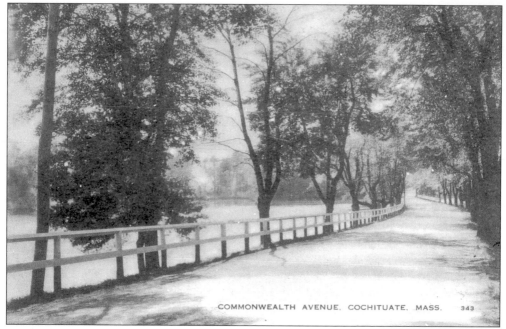

COMMONWEALTH AVENUE, COCHITUATE, MASS.    343

Wayland residents had plenty of attractive places for a Sunday drive. This is the "shore drive" along Lake Cochituate, heading toward Cochituate on Route 30.

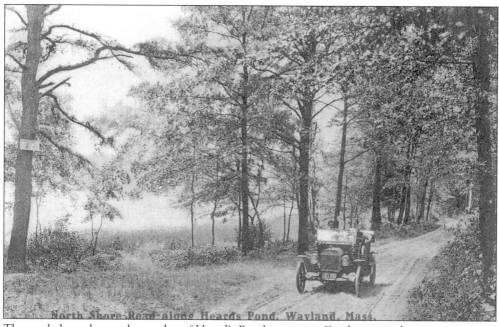

North Shore Road along Heard's Pond, Wayland, Mass.

The road along the northern edge of Heard's Pond seems to offer the same pleasant experience but a somewhat rougher course.

44

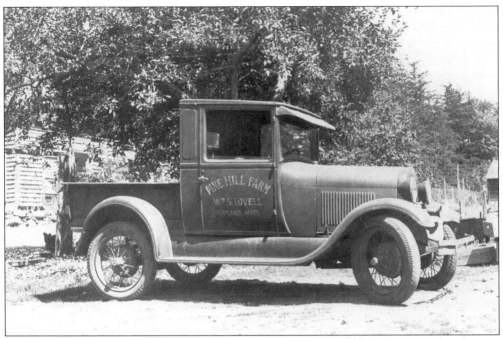

Bill Lovell's father, Lorenzo Lovell, bought Pine Hill Farm on Old Sudbury Road and ran it while he lived with his family next to his grocery store in Wayland Center. He used this early pickup truck to carry produce to his market and, perhaps, to Quincy Market in Boston.

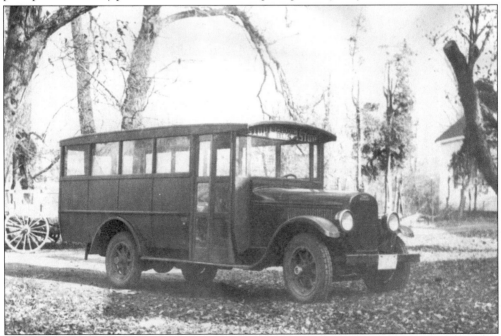

The wagon wheel visible behind this early bus suggests that we are in the transition period between the horse-drawn and gasoline-powered eras. Andy Paul of Sherman's Bridge Road drove this vehicle as a school bus but also offered regularly scheduled runs from Wayland Center to Waltham.

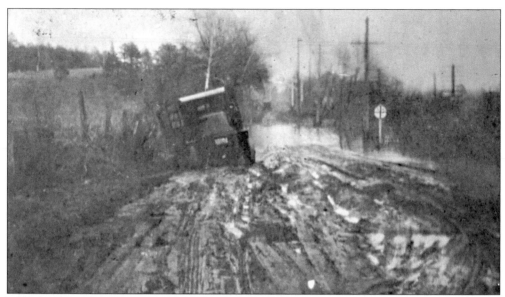

Mud was one of the great drawbacks to travel on dirt roads. This Mack truck has slipped off Route 20 just west of Russell's Crossing in the spring of 1920. Rapid melting of a recent storm was the cause of this quagmire. The low hill at the left rear was removed when that site was chosen for the new Raytheon Laboratory in the 1960s.

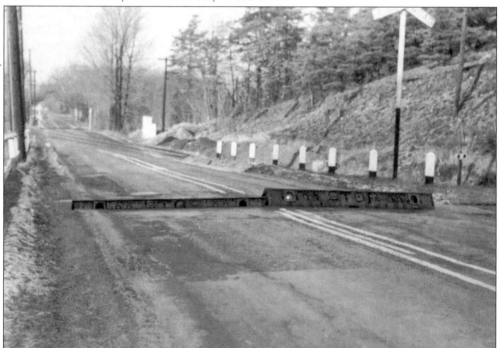

Wayland had four railroad grade crossings, the farthest west being Russell's Crossing near the Sudbury River. Deaths from railroad accidents skyrocketed with the growth of the automobile. Massachusetts experimented at this crossing with a large steel ridge that rose up from the road when activated. Gov. James Michael Curley came out to dedicate it. Soon afterward, the contraption was removed.

Wayland has three mileposts along its section of Old Connecticut Path. These stones were placed during the tenure of Benjamin Franklin as postmaster general for the Crown. Milepost No. 18 is located across the street from the present high school. Ground zero for distances was a stone located not far from Quincy Market in Boston.

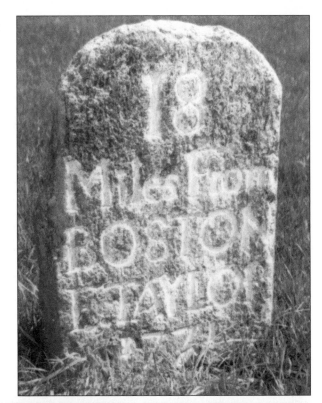

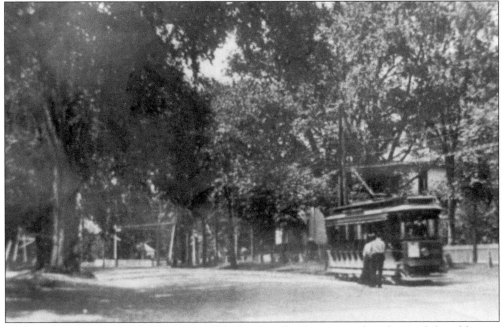

In this photograph, the Cochituate-to-Wayland trolley has stopped in front of the old town hall, reversed the contact with the overhead wire, and started to pick up passengers for the return trip. The single-track line was opened in the summer of 1899. Trolleys carried students to the new high school in Wayland Center until the line terminated service in 1921.

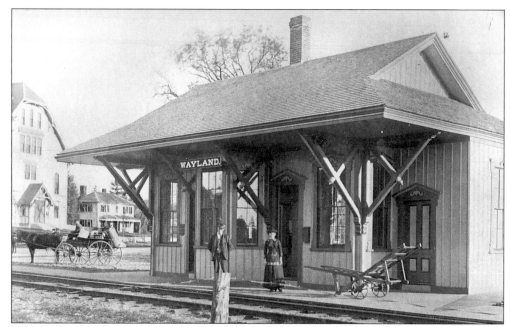

The Wayland Depot was built in 1881, when service commenced on the new Central Massachusetts Railroad. The design, with its elaborate roof-overhang braces and a board-and-batten exterior, was used elsewhere on the line. After the branch ceased operation in 1980, the Town purchased the building and leased it to a nonprofit craft and gift shop, appropriately called the Wayland Depot.

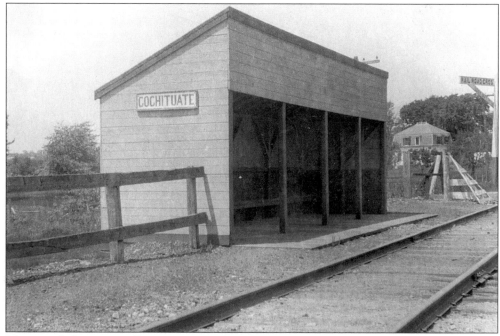

This tiny shelter, not really a station, was built in Framingham (Saxonville) on an extension of the Boston and Albany Railroad. The site was called Cochituate Crossing. The line and its shelter had very little impact on Cochituate Village.

The Tower Hill Depot was built in response to the needs of families who had moved into the area, as well as those of local old-timers who had promoted the line. It had a full-time agent and gate tender. The structure at the right was built to provide some shelter for commuters after the station had been closed.

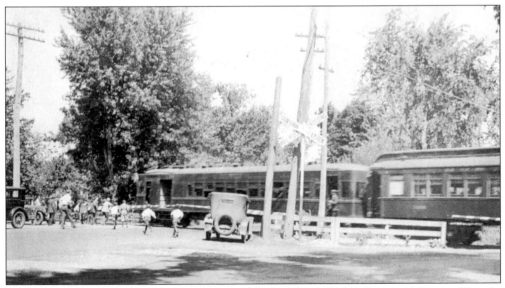

This 1925 photograph shows a passenger train blocking both Old Sudbury and Concord Roads. The warning sign says, "Stop and Look—Railroad Crossing." It took two sets of hand cranks to put all eight wooden gates down.

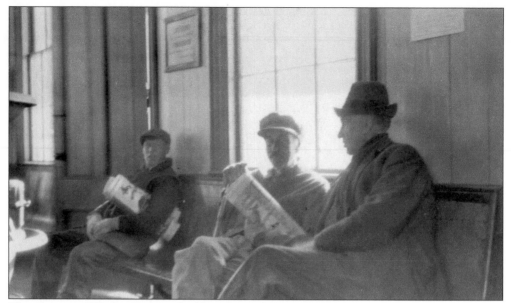

The interior of Wayland's depot had benches on three sides, all facing a large coal stove. A big station clock with a pendulum hung on the wall. The oiled floor gave a distinct depot aroma to the room.

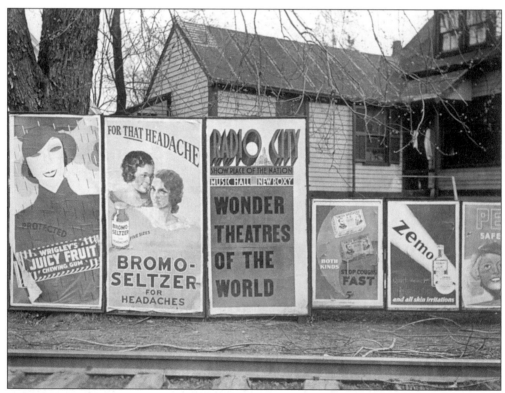

Across the tracks from the loading platform and along Mrs. Dickey's fence, a row of posters livened up Wayland Center's landscape, including one from Radio City Music Hall.

# *Four*
# GETTING TO KNOW YOU

Carrie Lee was both the principal and teacher at the Rutter School on Pine Brook Road. Her family lived only a short distance away on the Post Road, so she did not need to board somewhere nearby. In the *c.* 1880 period, she averaged 30 students and was paid $9 per week. At that time, Wayland's annual per-pupil expenditure was $13.45. Firewood was an important budget item.

Edmund Hamilton Sears served as minister of the First Parish in Wayland Center for 17 years (1850–1867). He is best remembered as the author of the carol "It Came upon a Midnight Clear." He was known as a dynamic preacher, poet, humorist, and above all, social reformer. He was an intensely religious man—sure that he was "doing God's work." He was a fiery abolitionist from the pulpit as well as in his writings.

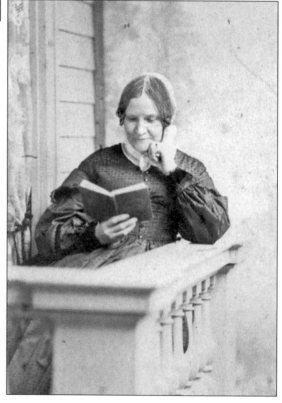

Lydia Maria Child was perhaps the most widely known Wayland personage of the 19th century. Among her literary achievements were America's first romantic novel, first magazine for young people, first practical cookbook, and first guide to housekeeping. However, it was her crusade against slavery that brought her to the attention of the nation. At her death, her will provided a gift to support women's voting rights. Nothing escaped her concern for social justice.

Our knowledge of late-18th- and 19th-century Wayland would be the poorer without the lifetime efforts of James Sumner Draper. Draper was a successful farmer, as well as a teacher, surveyor, librarian, and tireless tree planter. When the town refused to erect a Civil War memorial, Draper sat down and wrote a history of every Wayland Civil War veteran, which he then published himself.

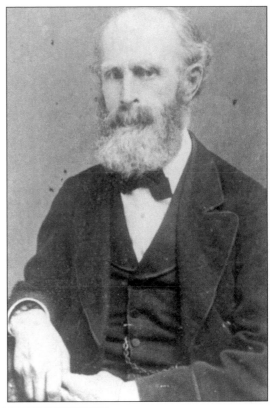

Anna Dudley was the young woman who painted the delightful watercolor that opens chapter one. She lived in a house, still standing, at the beginning of Old Sudbury Road. Among the many skills that a young lady might develop at that time were drawing and painting.

John Burt Wight came to Wayland in 1814 as the minister of the First Parish and oversaw, during his tenure, not only the establishment of the Trinitarian Congregational Church as an independent organization, but also the cessation of public money to support his church. He was a strong supporter of public schools and libraries.

Judge Edward Mellen came to Wayland as a young lawyer and began his career in the small law office in Wayland Center. While visiting his alma mater, Brown University, Mellen met the president, the Reverend Francis Wayland, who had visited Wayland several times and who proposed a gift of $500 to the Town toward a public library. Mellen responded that the townspeople should be required to match the unusual and generous gift.

The Reverend Francis Wayland served as president of Brown University in the early 1800s. When his proposed gift was announced in Wayland (see previous photograph), an amazing number of small donations more than met the requirement to match his gift. A number of Wayland's books on theology and education are housed in the Wayland Library.

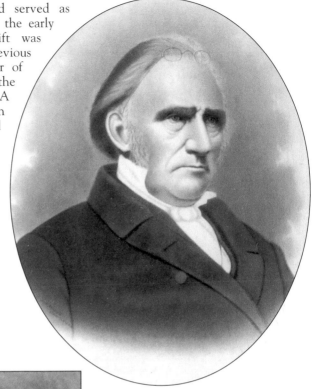

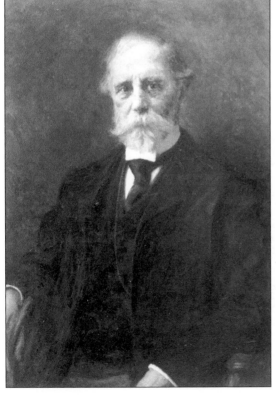

Warren Gould Roby was descended from an old Wayland family. He was one of a group of late-19th-century residents interested in town improvement projects. In 1898, his will provided for the gift of a plot of land and $25,000 to build a new public library on Concord Road. Samuel Mead was selected as architect, and the building was completed and opened in 1900—under budget.

Beatrice Herford was a member of a Boston family who summered in Tower Hill. She married Sydney Hayward of Wayland, and they built a home on the Boston Post Road. Beatrice was very interested in the theater, specializing in the then popular monologue. She enjoyed a successful career, eventually building the miniature Vokes Theater next to her home.

The private theater that Beatrice Herford Hayward built in the early 1900s may have been miniature, but it possessed every feature of a real theater, including a proscenium arch, a stage, banked seats, a balcony, and box seats. An active theater company now uses the building, and the tiny kiosk Dribbly Nibs, visible at the far right, still serves cold drinks at intermission.

Alfred Wayland Cutting retired to Wayland after a successful business career in Boston to take up a life of photography, horses, and writing. His photographs—of landscapes, personages, public events, and architecture—earned him a modest reputation and provided illustrations for a number of books written by his contemporaries on historical topics.

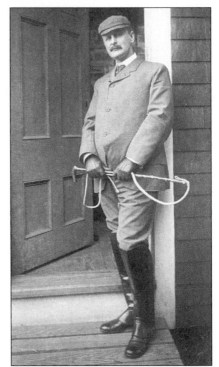

This room in Alfred Wayland Cutting's home illustrates aspects of his life: a saddle, some harness, his camera and tripod, works of art (some probably his own), colonial furniture, guns, and knickknacks from trips abroad. Ever a bachelor, he died in 1935.

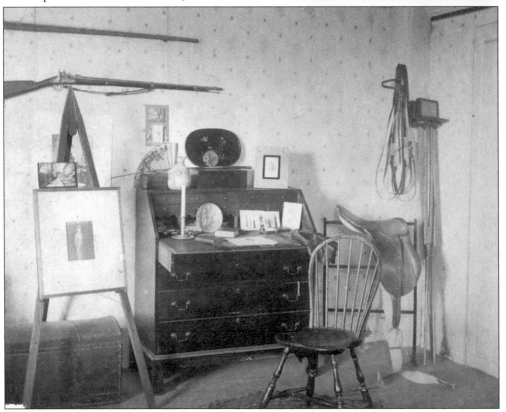

Alfred Wayland Cutting particularly enjoyed photographing children and people in costume. (See the cover of this book.) Here, he poses Harriet Richardson and Joan Kenney in colonial garb at his doorway. Harriet Richardson had a legion of friends in Sudbury and Wayland and was a mine of historical information about the town. For years she was a telephone operator in Wayland's central office. (Photograph by A.W. Cutting.)

Wallace Draper Folsom, seen here as a youngster, was a chronicler of Wayland's daily life during his adult years. With a folding Kodak camera hanging about his neck, Folsom strolled about Wayland, photographing everyday people and their homes and gardens, as well as street repairs, excavations, public events, and floods. If he took your picture one day, he would be back with it the next—at a very small price.

Elizabeth Heard Russell was one of the last grandes dames of Wayland. Perhaps the last of the Heards to be born with that name in Wayland, she worked as a writer and editor in New York before returning home to pose in front of the Daughters of the American Revolution–George Washington monument in Wayland Center.

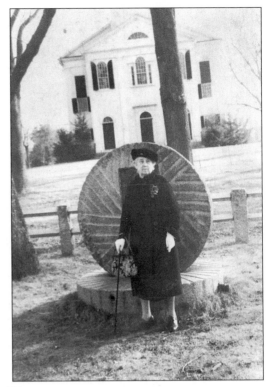

If Elizabeth Heard Russell was a grande dame, Daniel Graham was the king of Wayland Center. Graham lived in the George Smith House with his wife and little dog. Since the busiest place in town, the post office, was next-door, Graham had a large and constantly changing audience with whom to discuss the weather, town politics, and advances in gypsy moth control. He enjoyed dressing well.

John Connelly was a major player in Wayland public life for more than a half century. In 1930, he was not only town moderator, but also a trustee of the library, a commissioner of trust funds, and a trustee of the Allen Fund. Residents from both ends of town looked to him for guidance in the increasingly complex issues of suburban growth.

John W. Leavitt (on the right) was a WWI veteran who served as selectman during the critical decades from the end of the Depression to the late 1950s. Here, he is being given an award from the Town by Gerald Henderson, a businessman and fellow selectman, who was himself instrumental in bringing the Raytheon Laboratory to Wayland.

Robert M. "Bob" Morgan was one of a small group of Boston businessmen who moved to Wayland just before WWII. He saw a bright future for Wayland and sought a position on the Wayland Finance Committee, where he served for many years. He was a strong-willed, no-nonsense person, but admirers and detractors alike admitted that he was fair-minded and effective.

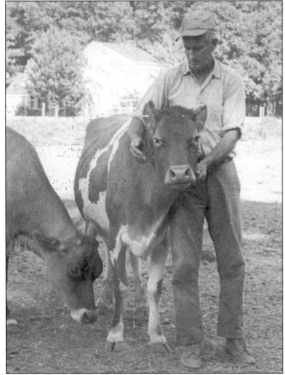

Walter Harrington and his wife, Dot Harrington, operated the last dairy farm in Wayland, milking a small herd (first by hand and then by machine), cutting and baling hay all over town, keeping a yard full of chickens and geese, and tending an extensive vegetable garden. Located on Plain Road, the farmhouse, barn, and garden still add to Wayland's rural atmosphere. (Photograph by Clifford Wedlock.)

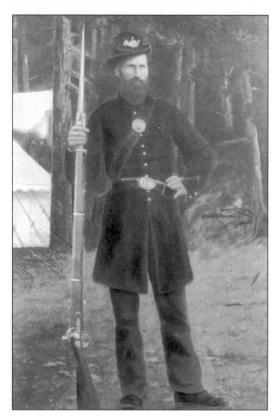

George T. Dickey was 35 years old and the father of three children when he enlisted in the Union army on June 29, 1861. Later that year, he fell ill while on duty in Maryland, and he died the following spring from pneumonia. Dickey was one of eight Wayland men to die during the Civil War, including one in the notorious Confederate prison in Andersonville.

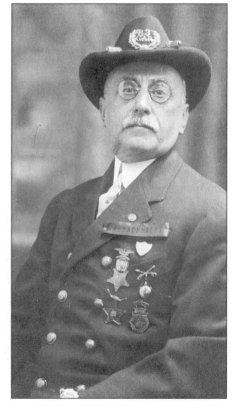

Charles B. Butterfield was a boy of 18 when he enlisted with his father, John C. Butterfield, in August 1862. The father was 46 at the time, and his other son, William Henry Butterfield, had enlisted the previous summer. By April 1865, Wayland had sent 78 men to war, and they had participated in nearly every major battle. Six men were captured, including Charles Butterfield.

Frank W. Draper was one of four Wayland Drapers to fight in the Civil War. Upon his graduation from Brown University in 1862, he enlisted in the army. Draper's years in uniform included almost every type of service, months of combat, serious illness, marching in review for Pres. Abraham Lincoln, and commanding a unit of colored troops. At war's end, he entered medical school and started an illustrious career as a surgeon.

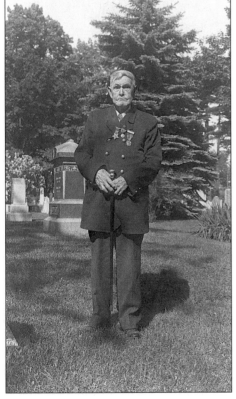

This stalwart veteran with a memorable countenance is George B. Howe, a Civil War soldier whose presence at the head of Wayland's Memorial Day parade made him one of the town's most popular figures. Howe was reportedly one of the last stagecoach drivers. His route took him from Marlborough through Wayland to the Stony Brook railroad station. (Photograph by Wallace Folsom.)

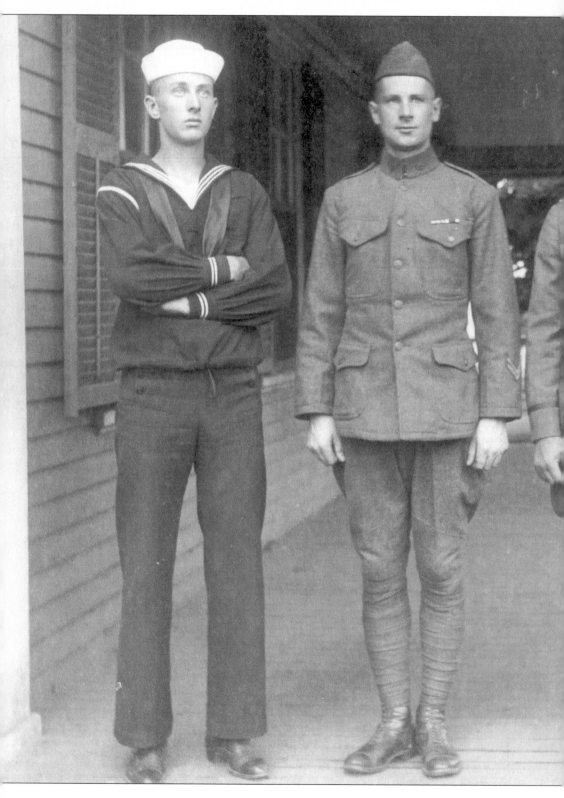

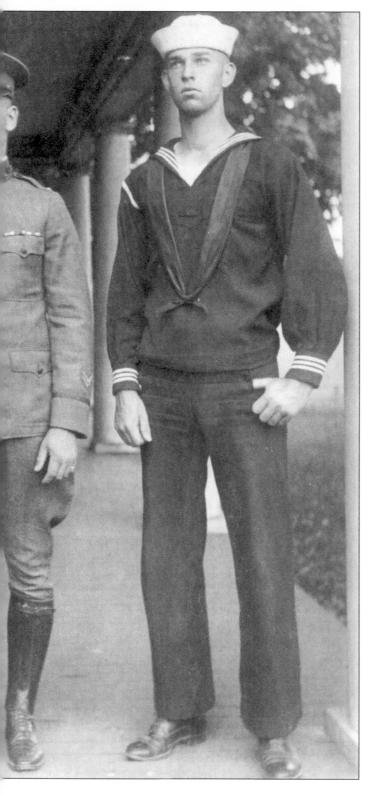

Four Morrell brothers pose on the piazza of their home on Old Sudbury Road at the end of WWI. They are, from left to right, Kenneth Morrell (navy), who went on to Tufts College, married Margaret Bent (Wayland historian), and became a businessman; Willard Morrell (55th Artillery in France and reenlisted in WWII, army air force); Malcolm Morrell (82nd Division, battlefield commission), who went to Bowdoin College and became coach and athletic director there; Allen Morrell (navy), who went to Bowdoin College and became a businessman. Only Kenneth Morrell remained in Wayland, staying with his family at 4 Main Street, Cochituate. (Photograph by A.W. Cutting.)

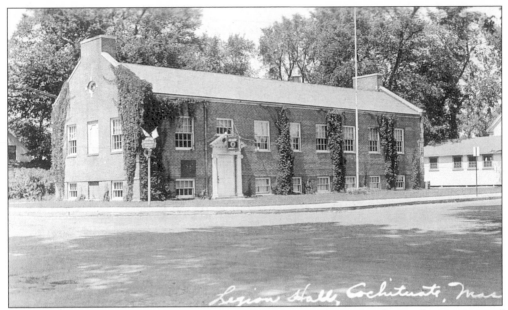

Legion Hall was an attractive public building in Cochituate, located at the northwest corner of Main and West Plain Streets, once the site of the Knights of Labor Hall. The newly formed American Legion erected this building for the Charles Alward Post No. 133. The post permitted other organizations to use the building and its meeting hall. After WWII, the structure was razed to make room for a restaurant.

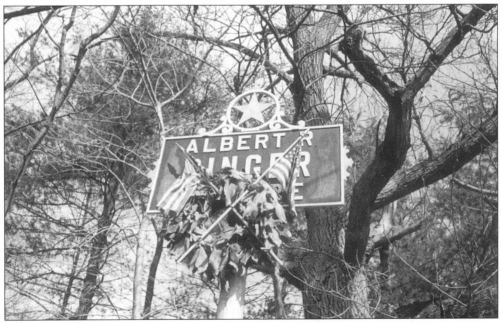

A number of veterans were honored throughout Wayland by signs erected at important squares or intersections. Albert Ringer, whose family lived nearby, was honored by this sign at the intersection of School and Main Streets, formerly known as Fiske Corner.

George Bogren was 17 when he joined a cadet unit at Harvard University during WWI, but the war ended before he went overseas. When WWII broke out, Bogren joined the U.S. Sanitary Corps and went to the Pacific theater to supply clean water to the troops. This photograph shows him in the Fiji Islands. In civilian life, Bogren served as a Wayland selectman and on several town committees.

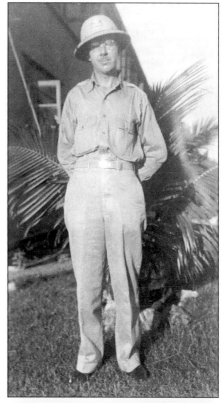

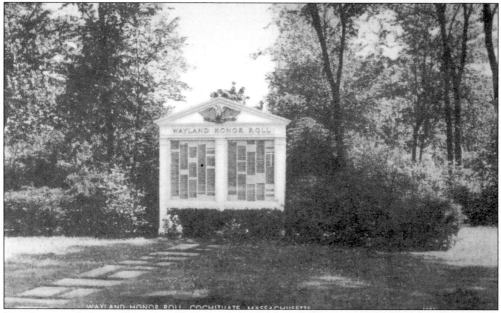

Two large and identical honor rolls were erected during WWII at both ends of Wayland. One stood near the Cochituate Fire Station and the other stood next to the Mellen Law Office on the green in Wayland Center. As the war progressed, more names were added; the names of men who died in combat were marked with gold stars.

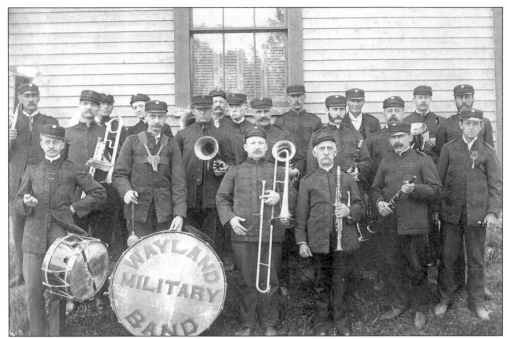

Bands, military or otherwise, have always been popular with the American people. The story goes that these talented musicians played at a memorial service for Pres. James McKinley. Among the men assembled here were a Wayland postmaster and a station agent at the depot.

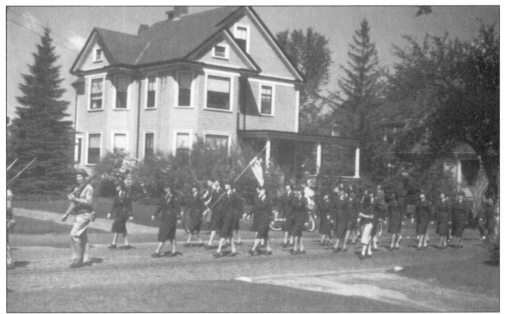

The 1943 Wayland Memorial Day parade steps off along Cochituate Road for South Cemetery. This unit is Wayland's Women's Auxiliary Motor Corps, led by Col. Letitia Vincent and flag bearer Carol Powning. PFC Don Rowan of the Massachusetts State Guard is in step on the left. The house belonged to Perley Glass and was demolished in the 1950s.

*Five*

# SEEKING SHELTER

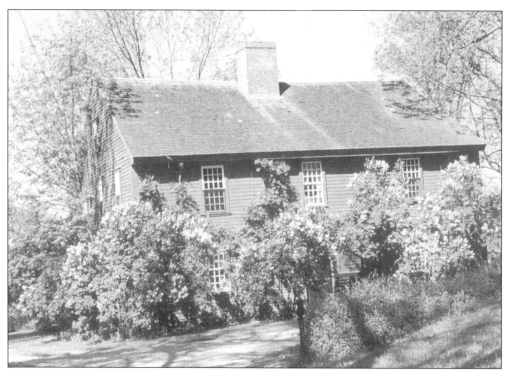

The Noyes-Parris House is the oldest building in Wayland. Like many very old houses, it was built in stages, the oldest part dating back to 1669. The house is located west of the Five Paths intersection on a colonial-era road abandoned long ago. Built by Peter Noyes, son of an original settler, it was occupied at one time by the Reverend Samuel Parris, a participant in the Salem witchcraft trials.

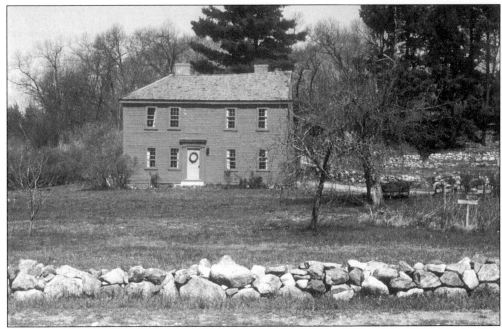

The Hopestill Bent Tavern was built c. 1710 on Old Connecticut Path, an early route from Boston to Hartford and beyond. It served as a residence and as a public house catering to travelers and locals alike. George L. Nolan was a mule driver in France during WWI. When he returned, he always kept a mule in the barnyard of his family farm.

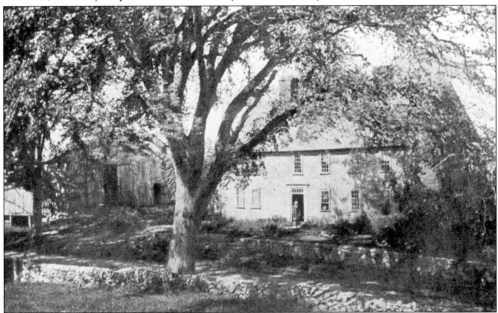

Reeves Tavern was another famous hostelry on Old Connecticut Path. Several of its structural features still exist. A wall on the second floor can be raised up out of the way to create a dance floor. Nearby was a stone-walled animal pound for travelers' livestock. Like many Wayland farmhouses, the tavern was eventually purchased by a Boston family, to be used first as a summer home and later as a permanent residence.

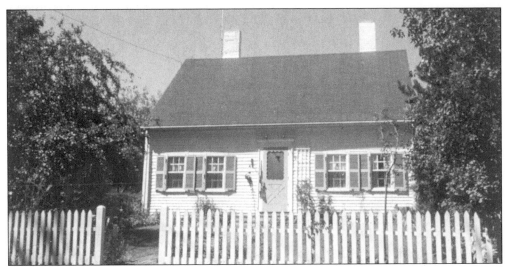

The Brintnal-Loker House is the oldest structure in Cochituate, built by Phineas Brintnal c. 1740. This part of Cochituate came to be known as Lokerville because of the prominence there of the Loker family. Capt. Isaac Loker commanded the Sudbury Troop of Horse and is said to have held training exercises in the field behind this house. The troop later participated in the events of April 19, 1775.

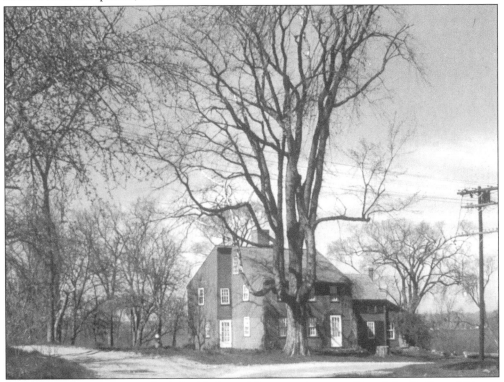

This diminutive house was built by Nathaniel Rice on the west side of the Sudbury River at about the time that Wayland separated from Sudbury. Rice and some neighbors wished to retain their ties to the east-side church, located at that time in Wayland Center. The irregular end wall lets sunlight into two rear rooms of the structure. Note the huge elm in the front yard.

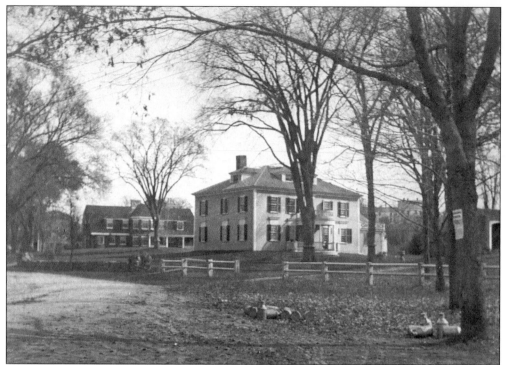

Located on the Boston Post Road, this imposing Colonial Revival residence contains timbers from the town's fourth meetinghouse, built in 1726. The house once served as a grocery store, and Wayland town meetings were held from 1821 to 1841 in a large room on the second floor. Known as Kirkside, the house was chosen in 1992 by WGBH as a restoration model for its *This Old House* television series.

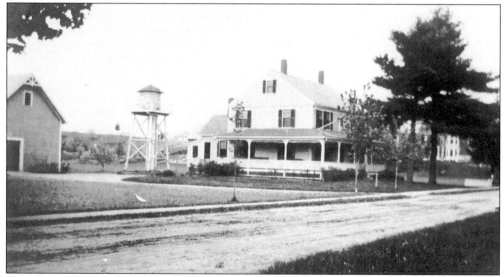

The Zachariah Bryant House on Old Sudbury Road lies at the edge of Wayland Center. On April 19, 1775, Bryant left his home with his musket and ammunition to march to the Concord fight. The simple farmhouse, built *c.* 1770, was renovated by one of Wayland's first physicians into an attractive country residence with a neat barn and elegant water tank.

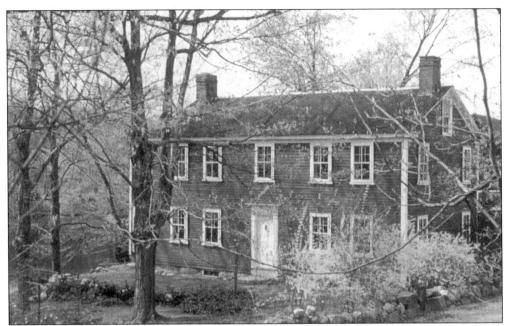

Edmund Rice came from England in 1638–1639 and settled near the present high school. Rice children went on to settle throughout Wayland, Sudbury, and Marlborough. Samuel Rice built this house in 1810 on Rice Road, near a mill on Snake Brook that his father had set up, using the brook for power. Several other Rice farms were established nearby.

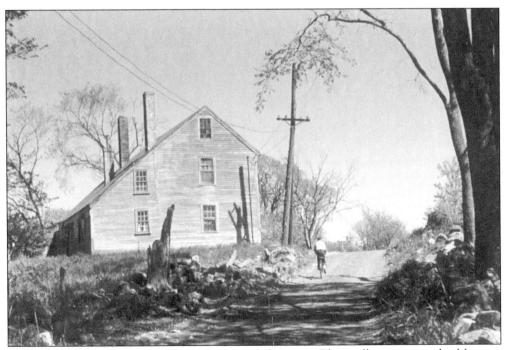

Not every colonial house in Wayland survived the years. This well-proportioned saltbox on Thompson Street in Cochituate lasted well into the 20th century, but it finally fell into disrepair and was torn down. The front of the house faced south, as did many homes of that era.

The Reverend Josiah Bridge built this handsome residence on Old Sudbury Road in 1761, after he had been called to the First Parish in Wayland Center. His ministry lasted for 40 years. Perched on a slight elevation, the house and its encircling veranda provide a fine view over the meadows to the Sudbury River.

This house at 136 Commonwealth Road was one of the earliest residences built in Cochituate Village. The building lot was sold to Otis Lyon by William Bent. Lyon ran a shoe shop in the backyard until he built a larger factory elsewhere. Later, the house belonged to Dr. Charles Boodey, a popular Cochituate physician who was very active in town government.

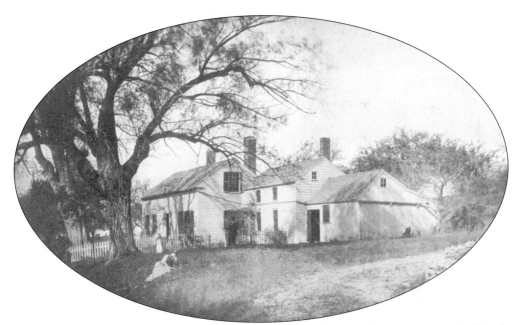

This simple country cottage was built in 1830 on Old Sudbury Road, where it provided lovely views of the Sudbury Valley. From 1852 to 1880, it was occupied by one of Wayland's most illustrious residents, Lydia Maria Child, who was a novelist, a poet, an author of America's first cookbook, a publisher of the first children's magazine, and a staunch abolitionist. (Photograph by A.W. Cutting.)

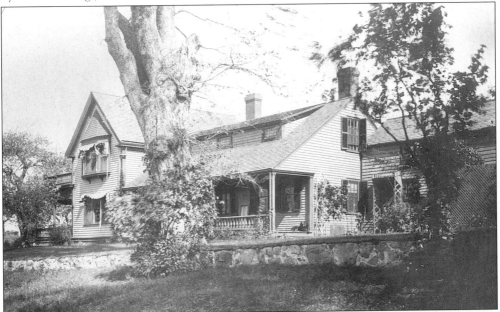

Eventually, the cottage shown in the previous photograph was "Victorianized." White paint probably gave way to browns and mauves. Awnings were added and a porch with a rocking chair. In the 1880s, Alfred Wayland Cutting, who summered in the house next-door, took possession of the cottage and made it his home, adding a tiny studio for his photographic work. (Photograph by A.W. Cutting.)

Frantic home building was set off all over Cochituate by the rapid growth of the shoe industry. The style of this substantial house on Main Street exhibits the then popular blend of Greek Revival, Italianate, and Gothic elements. It was torn down to make way for St. Zepherin's Church.

Another solution to the problem of housing workers and their families was the multifamily tenement. Few of these were built, and, surprisingly, this one, called the Beehive, still exists. Moved at least once, it now sits on Bradford Street. Rooming houses were another solution, particularly for single men.

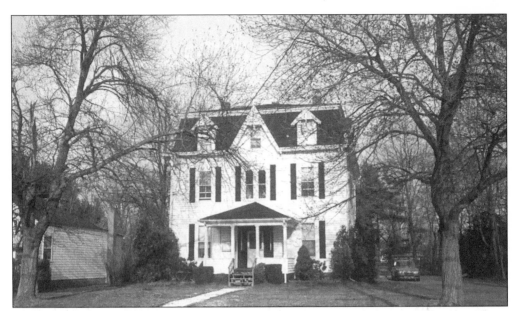

This sturdy, well-proportioned house on Main Street might be said to exemplify the dwellings of upper-middle-class Cochituate in the late 1800s—factory division managers, lower- and middle-level corporate officers, and key sales and financial employees. The roof is that famous mansard style that took Cochituate (and other cities and towns) by storm. The building still stands.

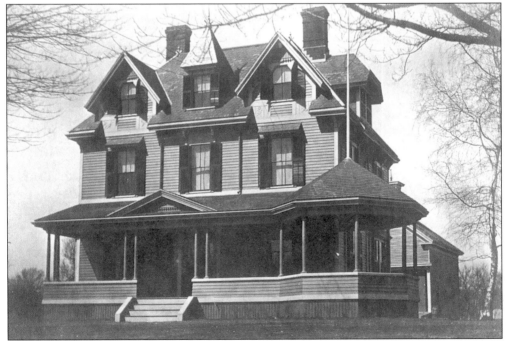

Commonwealth Road attracted the majority of the mansions that Cochituate factory owners built in the heyday of the shoe industry, and several of these have survived in excellent condition. This grandiose home was built by Alfred H. Bryant in 1879 in an exquisite Queen Anne style. For a while, Bryant had a good-sized shoe shop in his backyard.

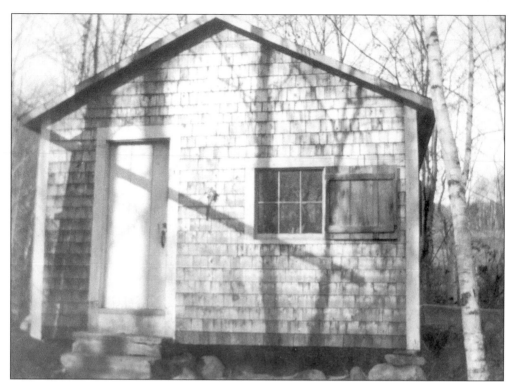

This 1920s photograph has "Hunting Shack, off Indian Road" written on the back. The road was one of a network of narrow dirt roads that encircled Dudley Pond, along which simple one-room shacks (known more often as camps) had been built between 1890 and 1930. The window cover indicates seasonal use.

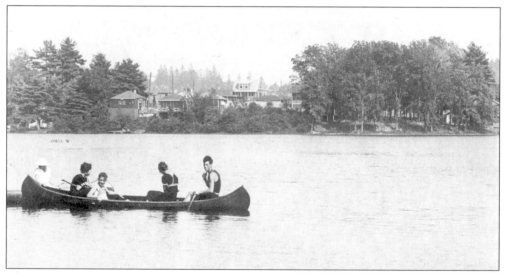

This group of pleasure seekers out in a canoe on Dudley Pond undoubtedly owned or were renting a camp somewhere around the pond. Many families came to the pond by streetcar, others by bus or car. Several small grocery stores opened near the pond, and there were canoes and boats for rent. During the Great Depression, many of these camps were converted to year-round use.

# Six

# IMPROVING
# SPIRIT AND MIND

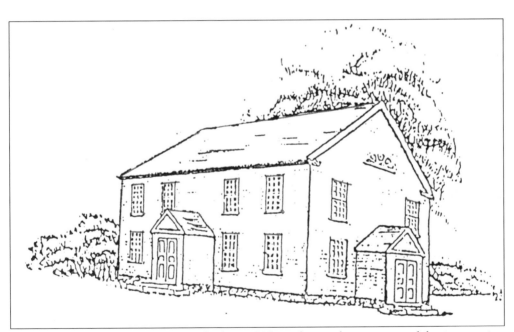

Wayland's fourth meetinghouse was built in 1725 on the northeast corner of the intersection
of Cochituate and Pelham Island Roads, about a mile south of the third meetinghouse in the
North Cemetery. The west side of Sudbury had just received its own meetinghouse, and the east
side had been made responsible for the religious life of some "Natick Farmers" who lived in the
Cochituate area. The building was a real "house" to meet in, not unlike contemporary
dwellings. (Drawing by Rita Anderson.)

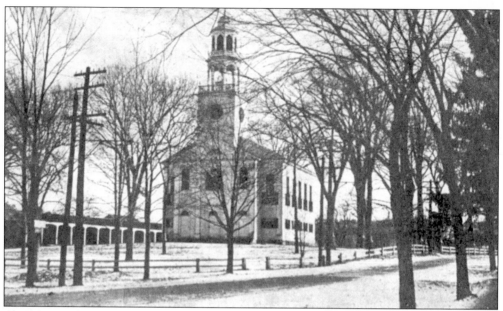

This church was the fifth place of worship for the First Parish in Wayland and was completed in 1815. The first three meetinghouses were located in the North Cemetery. The design came from the architect Asher Benjamin's "pattern book," *The Country Builder's Assistant.* At the far left, a portion of the church's carriage sheds can be seen.

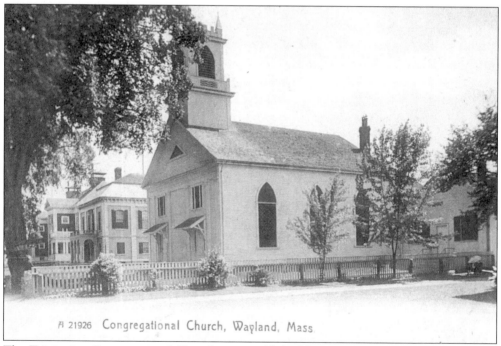

A 21926 Congregational Church, Wayland, Mass.

The Trinitarian Congregational Church was established by a group of parishioners from the First Parish who sought a more traditional service. They met in family homes and then in a small chapel until this new church (with two rows of carriage sheds) was completed in 1835. The design of the church, with its tower and Gothic windows, was greatly popular at that time.

The members of the Trinitarian Congregational Church, whose place of worship had been destroyed by fire in 1922, met for the first time in its replacement in 1928. The building was designed by well-known Wayland architect Edwin B. Goodell Jr. Rapid membership growth after 1945 led to several additions, including a large parish hall and the purchase of two neighboring buildings.

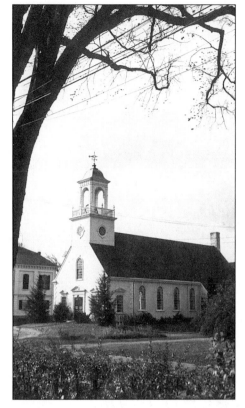

The Lokerville Wesleyan Methodist Church, shown behind the sleigh, was organized by a group of Cochituate residents who wanted a Protestant church in the southern part of town. For a while, they met in classrooms in the Lokerville (or South) School, shown at the left; in 1850, they held the first services in their new place of worship.

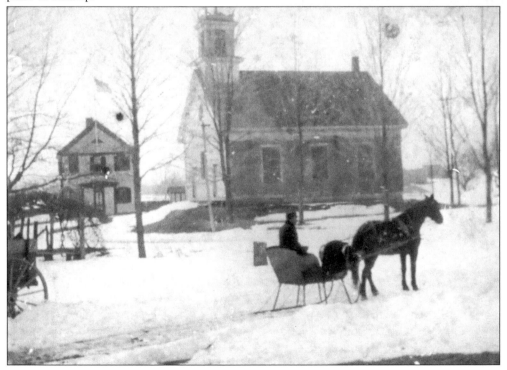

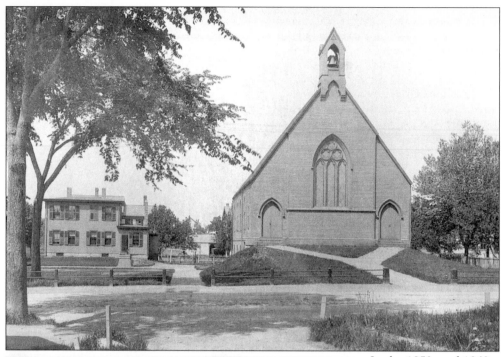

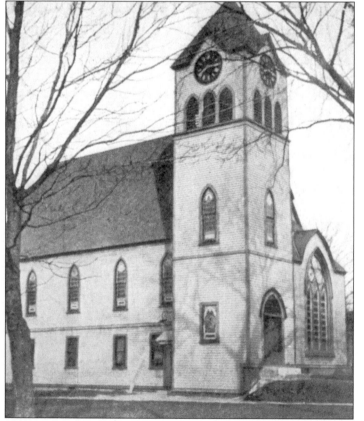

In the 1850s and 1860s, newcomers to the Bentville neighborhood of Cochituate thought that the Lokerville church was too far away and decided to form the Methodist Episcopal Church. By 1869, they were meeting in a smaller version of this building, which was enlarged in 1873. The house at the left was the parsonage.

The renovations to the church in the previous photograph included the addition of a tower, the installation of the official Cochituate town clock, and the placement of several beautiful stained-glass windows.

The number of Catholic families in Cochituate increased substantially during the second half of the 19th century. In 1889, a new Catholic church was authorized, to be named for St. Zepherin. Construction was started on Willard Street, and a residence for the priest was purchased next-door. After nearly 70 years of faithful service, this spare Gothic building was razed.

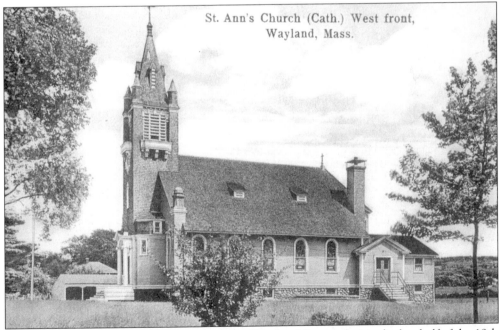

St. Ann's Church (Cath.) West front, Wayland, Mass.

Large numbers of Catholic families moved into Wayland Center during the last half of the 19th century, primarily to work on farms and the new railroad. In 1905, there were enough congregants to build this handsome church, St. Ann's, with its splendid stained-glass windows, on the Boston Post Road west of the center. A row of carriage sheds was included. The building was razed in 1967, when a new church was completed on Cochituate Road.

This small brick house on Pelham Island Road was one of several one-room schoolhouses scattered throughout Wayland in the first half of the 19th century. Youngsters who lived around Wayland Center attended this school until they were shifted to the Center Primary (Street) School on Bow Road. This building still stands, greatly altered, next to Benson's Coffee Shop.

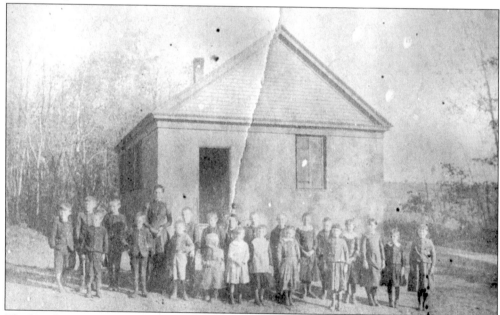

The North School, also made of brick, was built near the intersection of Concord and Lincoln Roads and was moved once as streets were realigned. The teacher in the photograph may be Amanda Baldwin, who wrote in her diary that she had to board nearby in order to teach here. Her weekly salary was about $8. Students from lightly populated North Wayland attended this school.

This school was built in Wayland Center in 1841 and was moved later to Bow Road. It was known as the Street School and accommodated about 30 students. After the completion of the Wayland High and Grammar School in 1897, this building was sold and converted into an attractive residence.

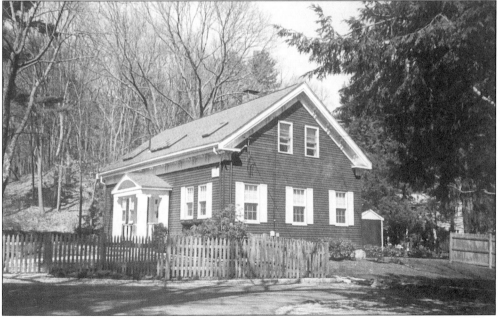

The Thomas School, named for a family that dominated this area in the 19th century, was one of several one-room schoolhouses built along Old Connecticut Path. Moved once, it remains today just southwest of the present-day high school, having been converted into a pleasant, up-to-date residence.

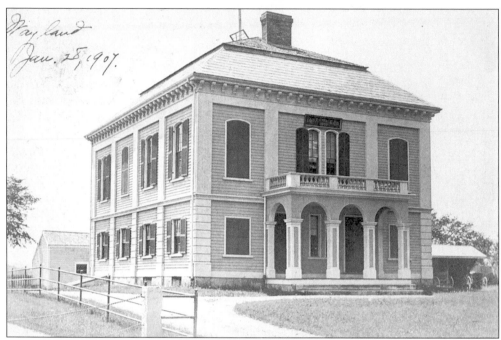

This was Wayland's first high school, built in 1855, as the Town acted to improve its school system. After a checkered career, the school was abandoned in 1896 and was then moved a few feet and sold for $200 to the International Order of Odd Fellows. Eventually, it became the property of the Trinitarian Congregational Church. (Photograph by Wallace Folsom.)

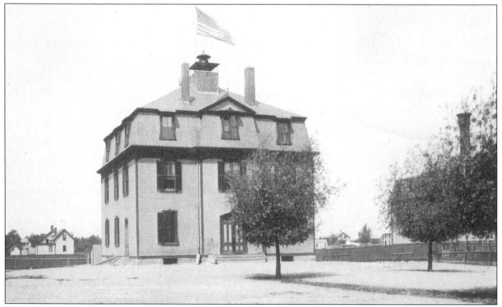

Wayland also responded to Cochituate's growing educational needs by building this sturdy structure on Main Street near Lyon's Corner in 1873. The hope was to accommodate primary, grammar, and high school students in one building. Labeled "Academy" on one contemporary map, the school gave a boost to Cochituate's self-image at the time. Town meetings were held here and in Wayland Center on an alternating basis.

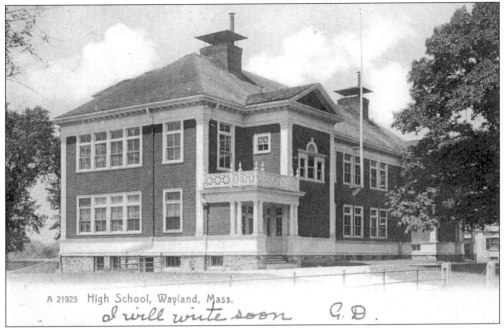

A 21925 High School, Wayland, Mass.
*I will write soon* G. D.

The Wayland High and Grammar School was opened in 1897 on Cochituate Road in Wayland Center. Four grammar school classrooms (two classes per room) occupied the first floor, and four high school classrooms were on the second floor. High school students from Cochituate arrived by trolley. Francis Shaw donated $8,000 toward the building's cost, which eventually reached $25,000.

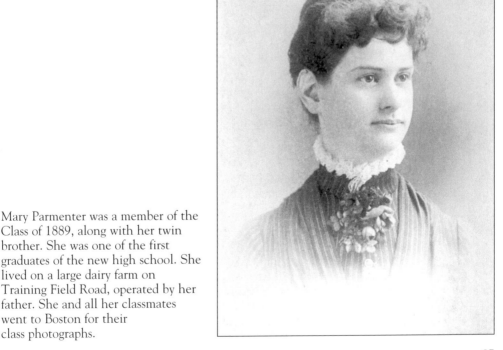

Mary Parmenter was a member of the Class of 1889, along with her twin brother. She was one of the first graduates of the new high school. She lived on a large dairy farm on Training Field Road, operated by her father. She and all her classmates went to Boston for their class photographs.

87

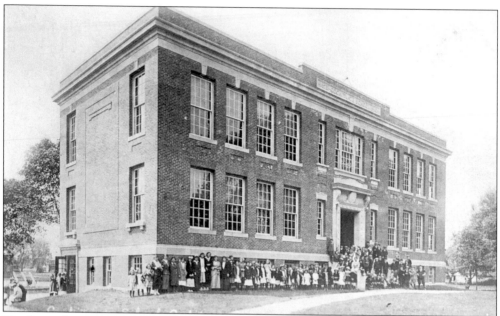

The first truly modern school in Cochituate opened in 1911. Over the next 67 years, this school gave hundreds of young women and men their start in education. Instead of tearing the building down, town officials voted to convert the well-built structure into apartments for older residents; Cochituate Apartments opened in 1983 with 56 units.

These students are the graduating Class of 1913 from the Cochituate Grammar School. Ernest Damon is the last boy in the middle row, Alfred Damon the last boy in the front row, and George Bogren the third from the left in the front row.

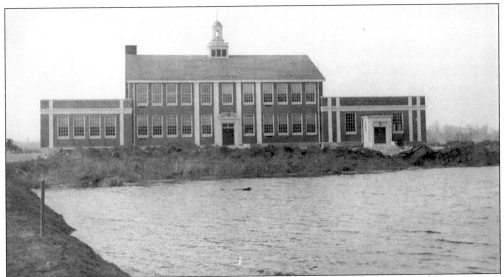

The need for a new high school was apparent by the late 1920s, but the cost was considered too great. During the Great Depression, a federal program to build municipal facilities enabled the town to construct this school in Wayland Center, and it opened in 1935. After many years of service, several additions, and, finally, the completion of the present high school, the building was completely renovated to serve as a town administrative building.

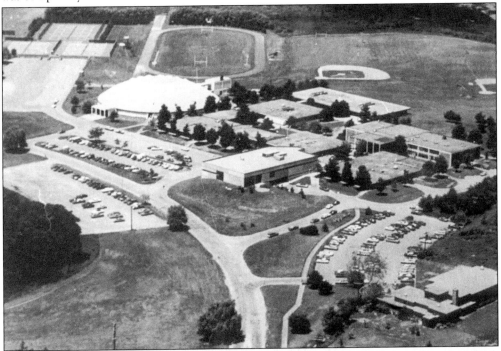

This extraordinary building complex was designed and built as the ultimate in American high schools. It opened in 1960. The low, one-story buildings, separated from one another, created a campuslike atmosphere, and the geodesic dome of the athletic center was a pacesetter for its time. A single library-and-administration building was added later. The extensive fields of the farm that had occupied this site provided playing fields for every sport.

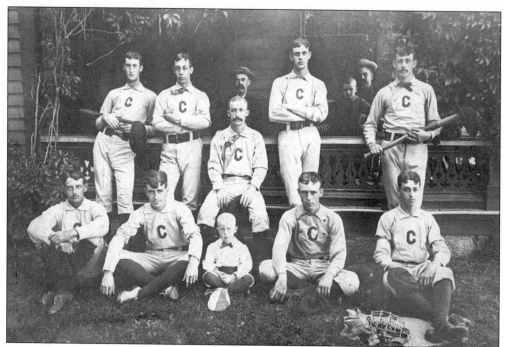

Baseball has always been a favorite sport of Wayland residents, from the days of the shoe factory teams to today's Little League. These members of an early Cochituate team pose with their mascot.

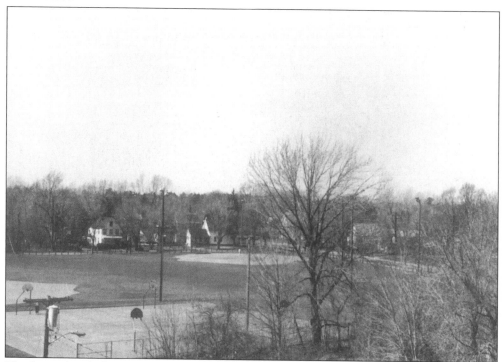

The former baseball field in Cochituate Village has been modernized to include two regulation diamonds with up-to-date lighting and two basketball courts.

The Wayland Lodge of the Odd Fellows sponsored this professional-looking team in the 1930s. This team played teams from neighboring towns, such as Weston and Lincoln, as well as other organizations, on the diamond next to the 1935 high school in Wayland Center. (Photograph by Wallace Folsom.)

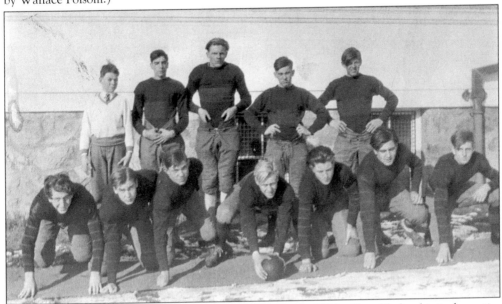

This is a Wayland High School football team of the early 1930s. Very likely, this is the entire team. The great rivalry then, as now, was between Wayland and Weston. The team is lined up next to the 1897 high and grammar school. Many of the team members have familiar last names, such as Perodeau, Gladu, Loker, Lyons, Yetton, and Wheeler.

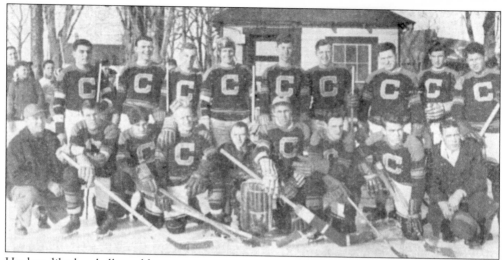

Hockey, like baseball, could generate teams not necessarily associated with schools. This team is the Cochituate Huskies, pictured in January 1940, with plenty of reserves and coaches. The team played on a rink on Main Street, near the baseball fields that can be seen in the background.

This is the Cochituate Huskies' rink, laid out on a vacant lot next to the Cochituate School, with a board fence, warming shack, and official scoreboard. Except for Cliff Wedlock, this was an all-Cochituate gang: Yeager, Butler, Richardson, Marston, Morris, Gladu, Perodeau, Neale, Bowles, Lindbohm, Fuller, Smith, and Flanders.

## *Seven*
# MAKING A LIVING

It was the lush grass growing along the Sudbury River that attracted the first English settlers, as cattle were to be the foundation of their life in the New World. A common way of storing hay was to stack it in mounds, called haycocks, like these along Wash Brook. Some farmers tossed a rope across the haycock with a stout stick attached, to reduce the loss by wind. (Photograph by A.W. Cutting.)

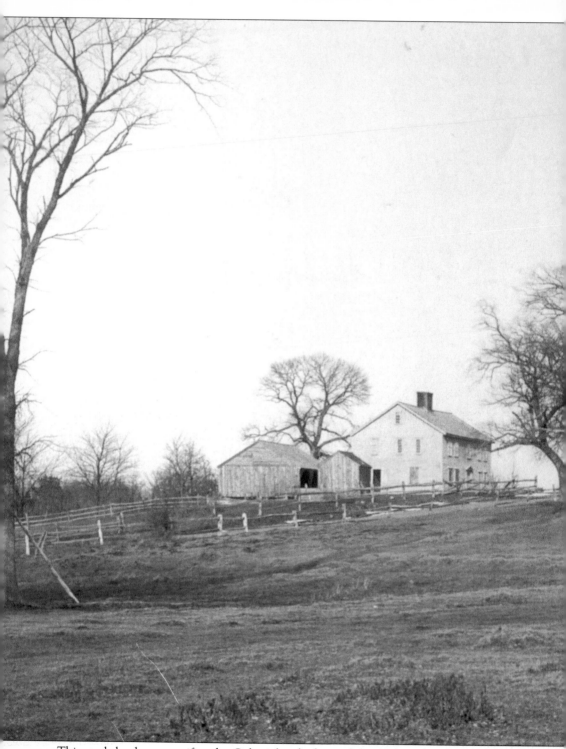

This stark landscape typifies the Colonial-style farm of the 18th and early 19th centuries: a stout, no-frills farmhouse with a central chimney and small windows, scattered outbuildings, and a good-sized barn. Built by Samuel Stone in 1715 at the end of Pelham Island Road, the

farm was occupied by Abel Gleason at the time of this photograph. The farmhouse was later given an extensive Colonial Revival upgrading by the Buckingham and Sears families. (Photograph by A.W. Cutting.)

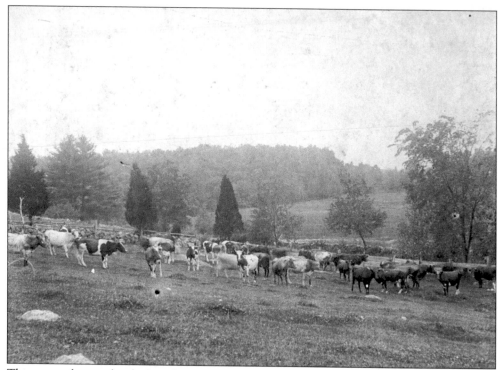

This scene shows a herd of cattle on the Irving farm on Old Connecticut Path. Holstein was the first choice among several breeds. Guernsey and Jersey herds were more likely to be found on "gentleman farms," such as Mainstone or Albert Beck's farm on Glezen Lane. This hillside is just behind the present Wayland High School.

These two huge barns on Bow Road sheltered Henry D. and Jonathan M. Parmenter's dairy cows, which often numbered more than 80. Grazing took place on the level fields across the road. The brothers also drove dry cows and calves to southern New Hampshire for the summer and then drove them back to Wayland in the fall.

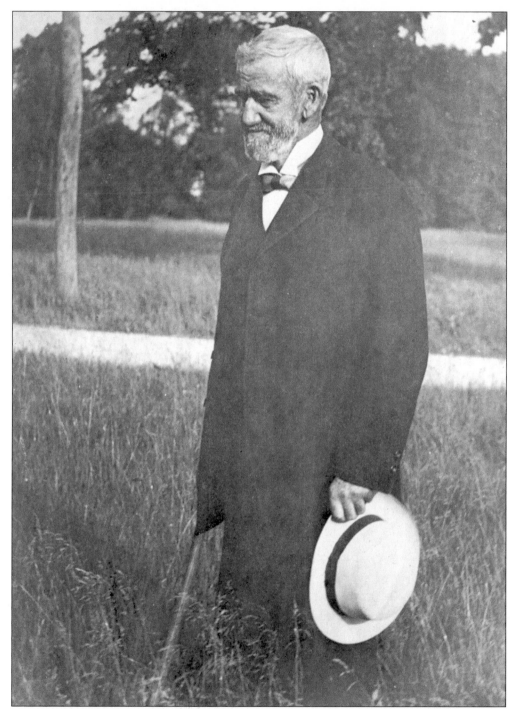

Jonathan Maynard Parmenter, shown here in old age, together with his brother, Henry Dana Parmenter, made a lot of money in farming. He invested his profits with the help of a banker friend and was found, at his death, to be a very wealthy man. His will bequeathed funds for the Parmenter Health Center, the construction of the North Wayland water supply system, and many college scholarships. (Photograph by Wallace Folsom.)

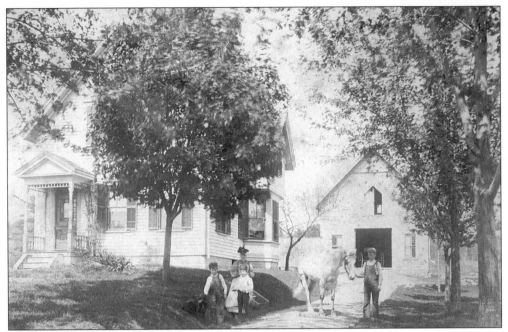

This peaceful domestic scene was photographed at the Lawrence family farm on School Street in Cochituate. This was one of the smaller farms in town, but it remained in operation until well after WWII. Eventually, the farm was sold to a developer, who had the house and barn razed and laid out a short residential street called Waybridge Road.

This handsome, relatively modern barn was one of the largest in Cochituate, built on the south side of Commonwealth Road and belonging to the Damon family. Thomas Jefferson Damon and his son, Isaac Damon, brought this large dairy farm to its peak during the early decades of the 20th century. Most of the fields and pastureland was developed after WWII as "Daymon" Farms.

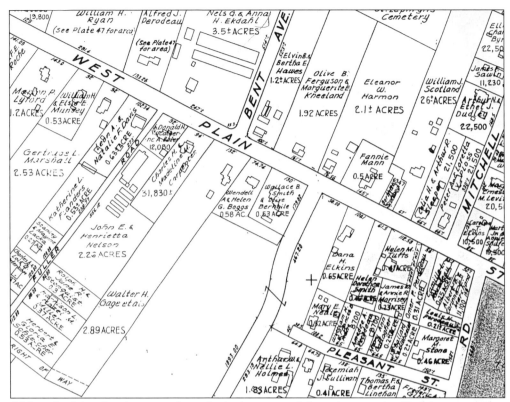

Although dairy farming was the principal source of farm income in Cochituate, market gardening was not far behind. Farmers such as Leonard Anzivino stuck to vegetables and his farm stand; others moved on to greenhouses and flowers. This section of a Wayland assessor's map shows the long, narrow greenhouses built by the Eckdahls on Bent Avenue and the Nelsons on Fuller Road.

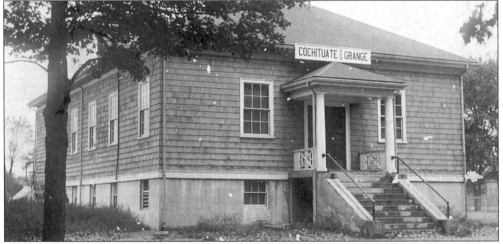

The Cochituate Grange was housed for many years in the old Knights of Labor Hall at Lyon's Corner. When that facility burned down, the Grange erected its own building behind the Cochituate School. As farming declined and school populations increased, the building and its land were taken over to provide for school expansion and parking.

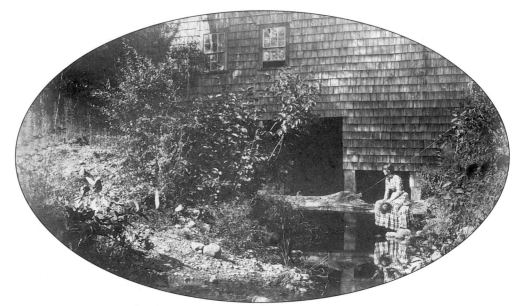

Alfred Wayland Cutting took this picture of his sister Madge Cutting, sitting alongside Mill Brook, where it exits from Wayland's oldest mill. Thomas Cakebread, who built a gristmill here in 1639, was the first in a long line of millers extending through the Grout, Reeves, and Wight families. All that remains today is the Mill Pond, one of Wayland's important landmarks.

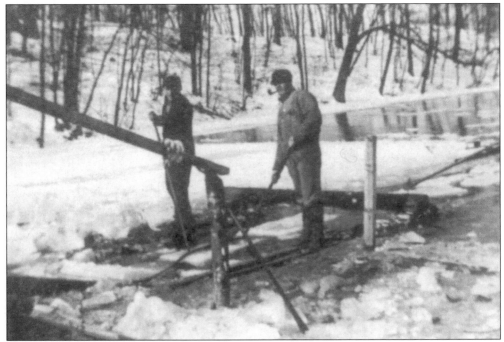

The practice of cutting ice goes back a long time in eastern Massachusetts. Wayland had at least three icehouses, including one on the Mill Pond in Wayland Center. Ralph Yetton and Ralph Morse are dragging rectangular cakes of ice to the icehouse ramp for Arthur Atwood's Coal, Wood, and Ice Company. Ice was delivered to households by wagon or truck during the summer.

Harry Wyatt ran the Cochituate Ice Company from his home on Main Street, not far from the large icehouse that stood on the shore of Dudley Pond near the end of Mathews' Drive. In winter, he drove an ice barge on runners through town, providing not only ice to customers, but also free rides to children.

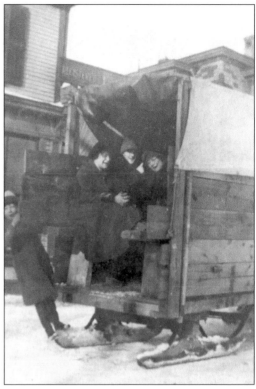

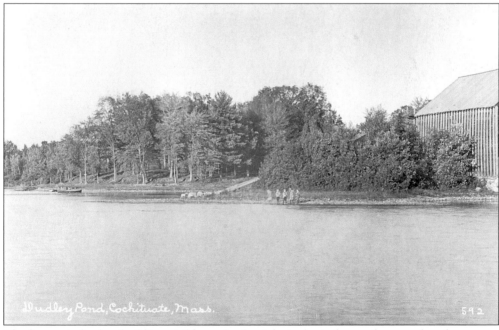

The large windowless building visible at the far right is the icehouse that stood at the eastern end of Dudley Pond. A portion of the chute along which ice was drawn into storage can also be seen. This cove had a crude beach that was very popular. Fishing, both summer and winter, boating of every kind, and skating were all favorite outdoor activities on Dudley Pond.

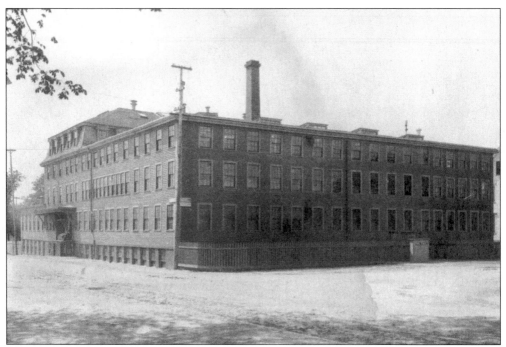

The William & J.M. Bent Shoe Factory at the center of Cochituate Village was the principal source of jobs in the entire town, even after several other factories were built. What appears to be a single building is a merging of three smaller structures, a shoe shop, a blacksmith shop, and a general store—all owned by the Bent family, who lived across the street.

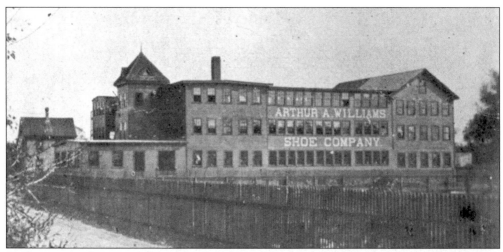

In the complex history of the Cochituate shoe industry, companies were regularly established, operated, and then sold. Factories were built on one site and subsequently moved to another. Arthur A. Williams bought this factory from Henry C. Dean, moved it a short distance away, and enlarged it to the size we see here. At peak production, the work force in this plant turned out 200 pairs of shoes a day.

The Edmund Lupien family occupied this worker's home on Dunster Avenue from the 1890s well into the 20th century. The house was within walking distance of every major employer in Cochituate. This area north of East Plain Street had been known as Scotiaville, due to the large population from Nova Scotia.

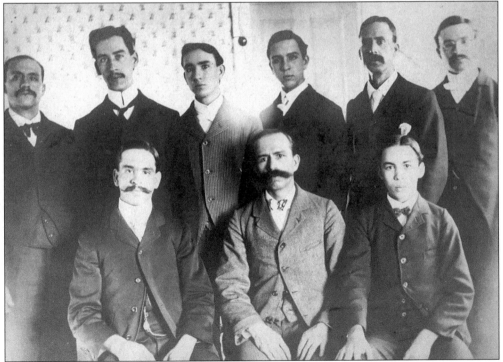

The Lupien family eventually grew to eleven children—nine boys and two girls. The brothers posed in their home for this remarkable photograph.

The growth of Wayland Center after 1900 provided local residents with jobs as carpenters, plumbers, store clerks, mechanics, maids, and chauffeurs. One of the most sought-after jobs was with the telephone company. This was Wayland's first telephone office, located on State Road West just beyond Benson's Coffee Shop. The building is still there, but with new tenants.

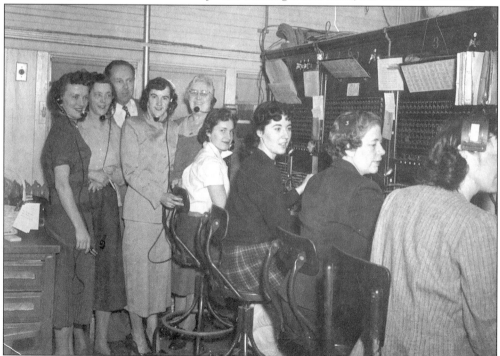

Cochituate originally received its telephone service from Natick. As a result, Cochituate customers got the 653 local service number and residents in the north end of town received 358. This room contained Wayland's switchboard, and these nine veteran operators are celebrating the arrival of dial service in 1954.

# *Eight*
# LEISURE TIME

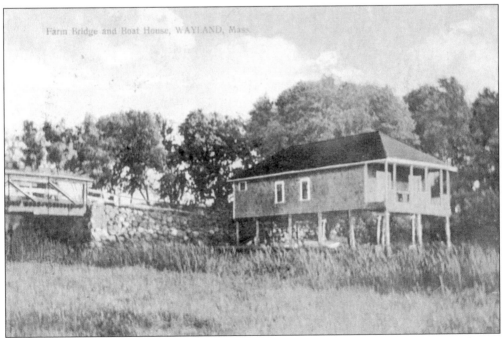

Boating on the Wayland stretch of the Sudbury River and on the two larger ponds was extremely popular, and it was possible to rent rowboats and canoes at several locations. This sturdy boathouse was located just west of the Farm Bridge on Pelham Island Road. There was another, smaller, boathouse on Heard's Pond.

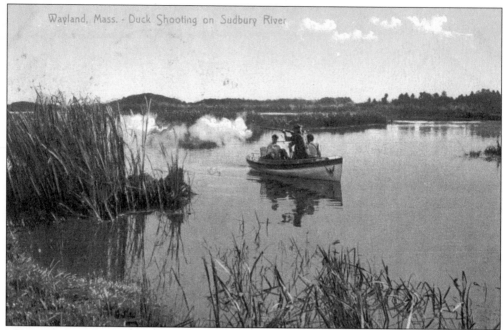

The Sudbury and Concord River Valleys are known as one of the major flyways for birds in North America. Flocks of waterfowl pass through twice a year and have long attracted hunters. The Great Meadows Wildlife Refuge, significantly expanded in recent years, permits seasonal hunting on sections of the refuge, as these gentlemen were doing years ago.

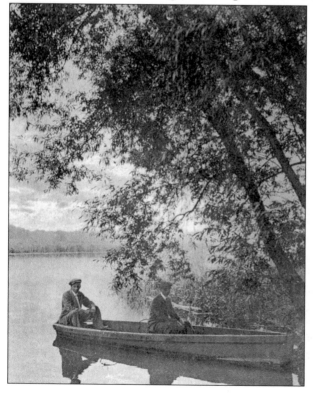

Wayland's two larger ponds have been especially attractive to boaters. These two men may have rented their rowboat in downtown Wayland near Benson's and been given a key to a padlocked boat secured to a tree at Heard's Pond.

Renting a rowboat in years past, regardless of the purpose, seemed to require a man to wear a jacket and a hat. A lady, in addition to a long dress and a stylish hat, also needed a parasol to complete her outfit. No one thought about life jackets. Some of Dudley Pond's popular summer camps are visible on the far shore.

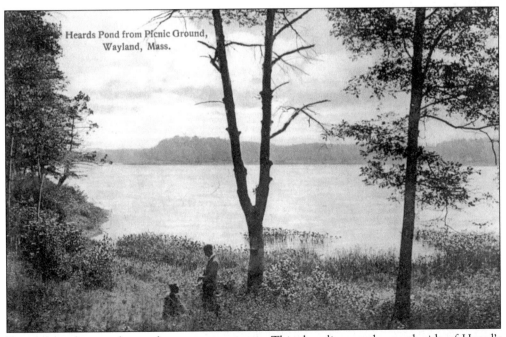

Heards Pond from Picnic Ground,
Wayland, Mass.

You did not have to be on the water to enjoy it. This shoreline on the north side of Heard's Pond provided a small peninsula where a blanket could be spread out and a picnic basket unloaded. There was always a view of the water and, with luck, a summer breeze.

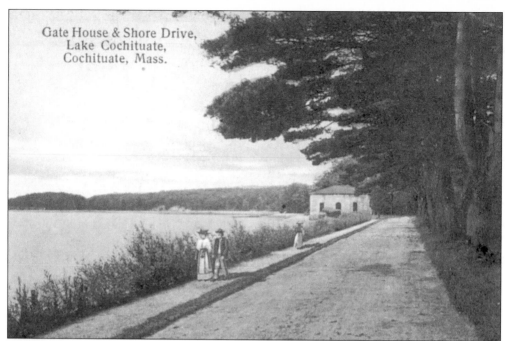

Gate House & Shore Drive,
Lake Cochituate,
Cochituate, Mass.

Lake Cochituate is a long, narrow body of water, once known as Long Pond. The name change took place when the mayor of Boston, who planned to acquire Long Pond water for his city, thought a Native American name might lend an aura of purity to it. The massive granite gatehouse in the distance governed the flow into the Cochituate Aqueduct and thence into Boston.

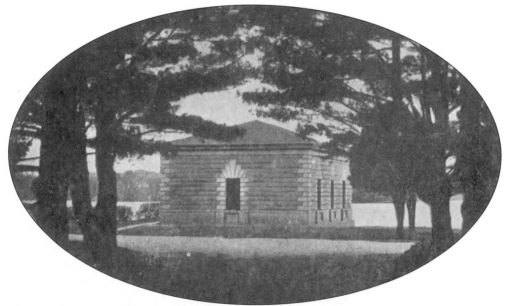

This is a closer view of the gatehouse in its woodsy setting. The City of Boston relinquished its control over Lake Cochituate after WWII and permitted the Town of Wayland to improve a sandy beach nearby, which became Wayland's public beach. Sailing is also very popular on the lake, and fishermen often line the wall near the gatehouse.

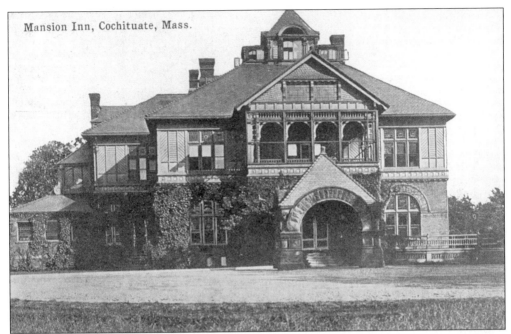

Mansion Inn, Cochituate, Mass.

Mansion Inn was one of Wayland's greatest landmarks. After many years as an opulent residence, it was converted into an inn, where there was dining, drinking, and dancing in a pleasant setting. A large wing with a fine dance floor was added onto the original house to enhance the nightclub atmosphere. The inn burned down in a spectacular fire in the mid-1950s.

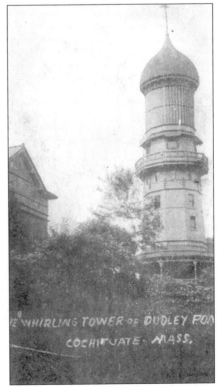

THE WHIRLING TOWER OF DUDLEY POND
COCHITUATE. MASS.

Michael Simpson, a wealthy industrialist and the builder of Mansion Inn, added this unusual tower to his landscaped grounds. It was known as the Whirling Tower and was long gone by the time the house had begun its entertainment era.

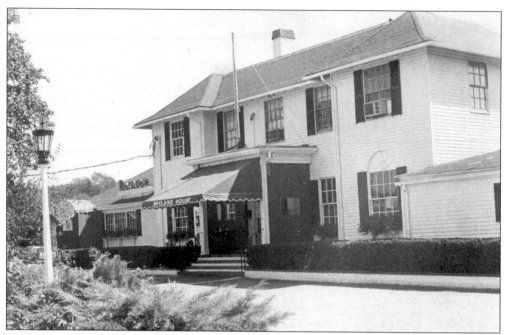

At the other end of Wayland, another roadhouse appeared in the early 1930s. It was located on the Boston Post Road near its intersection with Pinebrook Road. It operated under several names as the owners came and went: Rosebud Gardens, Terrace Gardens, Seiler's Ten Acres, and the Wayland House, seen here sometime in the 1970s.

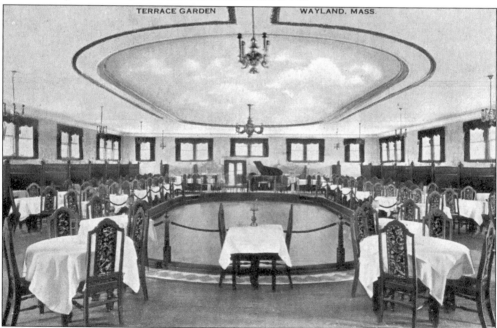

Terrace Gardens appealed more to patrons from Boston, Newton, or Wellesley than to those in Wayland. Dining and dancing in an attractive yet formal setting like this one, especially away from familiar surroundings, made this supper club a popular destination. For several years, Vaughn Monroe and his band were the main attraction.

Terrace Gardens also attracted local sports teams and fans. The Boston Redskins, a very early ancestor of the New England Patriots, practiced on the great lawn on the east side of the main building. Down behind, one owner laid out a regulation baseball diamond with bleachers. In the 1990s, a newly formed temple, Shir Tikva, bought the site and converted it for religious use.

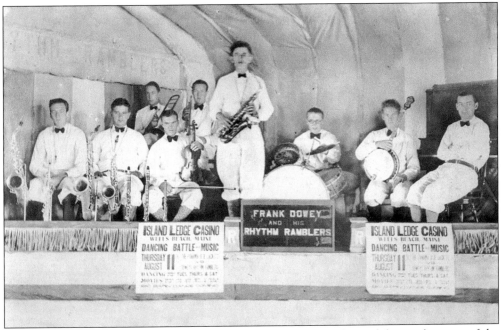

Frank Dowey was a Wayland boy with a love for music who made good during the years of the Great Depression. The Rhythm Ramblers and similar bands provided popular music for a wide variety of events at places such as Island Ledge Casino in Wells, Maine.

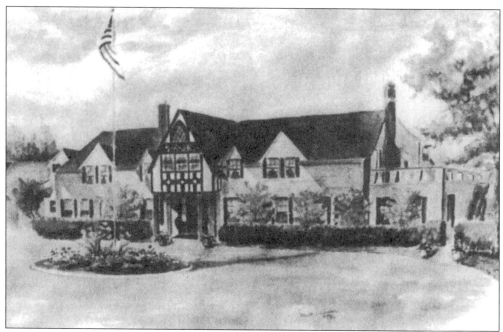

The Sandy Burr Golf Club course was designed in 1922 by Donald Ross, a well-known figure in that profession, on land that had once been two Wayland farms. Over the years, the course gained a reputation as an interesting and challenging 18 holes. The original clubhouse remains virtually unchanged today.

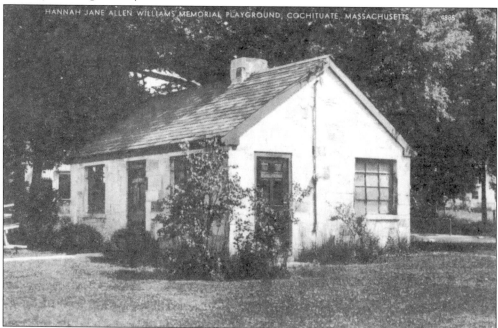

This is the original building at the Hannah Williams Memorial Playground on Main Street in Cochituate Village. In 1920, members of the Williams family razed several buildings to create the playground at this site. In recent years, the park has been enlarged and renovated, and this building has been removed.

# Nine
# LOCAL CATASTROPHES

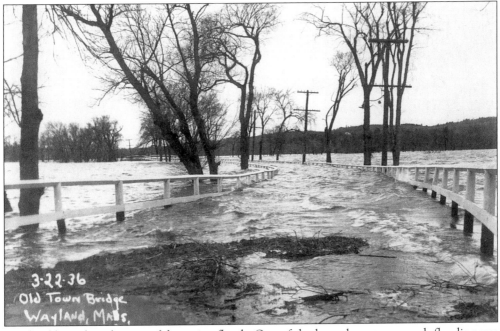

3-22-36
Old Town Bridge
Wayland, Mass.

Wayland has a long history of damaging floods. One of the best places to see such flooding was at the long causeway on Old Sudbury Road (Route 27) near the Wayland Golf Club, much of which was also underwater. This 1936 photograph was taken from the highest point on the old Town Bridge. Beneath the choppy surface is a strong current surging over the pavement.

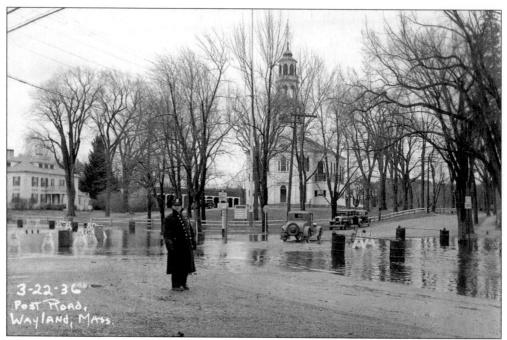

Residents of Wayland Center were used to having their principal intersection underwater every 10 or 15 years. The Sudbury River is one-quarter mile away but, in 1936, its waters backed up Mill Brook across Route 20 and Cochituate Road. Wayland's only full-time police officer, Frank Moore, was handling the traffic situation.

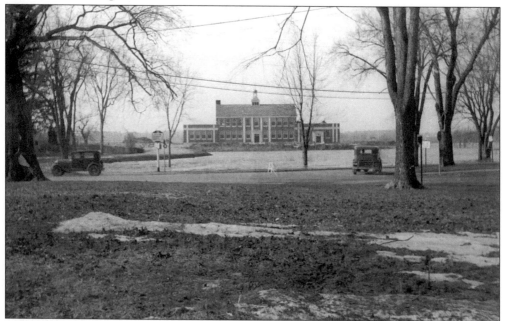

In this photograph, taken from a point near today's Public Safety Building, the then brand-new high school appears to be floating in water. One reason that the school had no basement was the very high water table in that location. The intersection of the Boston Post Road and Cochituate Road is located between the two automobiles.

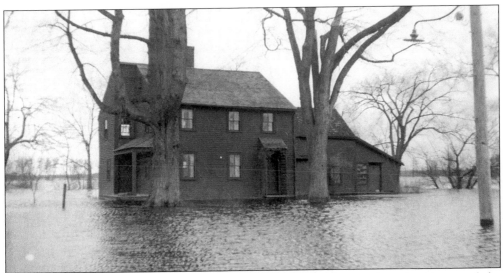

Few Wayland residents were actually flooded out of their homes, but the owners of the Nathaniel Rice House on River Road were not always that lucky. Local residents who used this road often stuck sticks upright along the edge of the road at high water to guide them across. Note the two large elms that were so common along Wayland streets at that time.

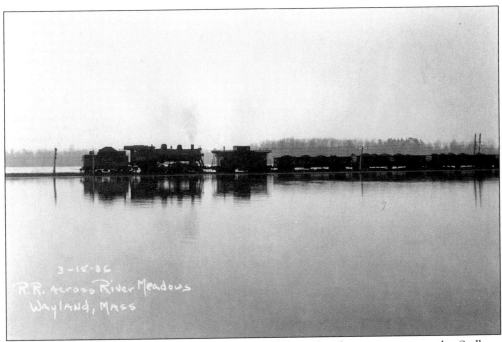

During the 1936 flood, engineers feared that the long railroad causeway across the Sudbury River floodplain might be breached and washed away. As a precaution, they filled a string of coal cars with sand and gravel and ran it out onto the causeway.

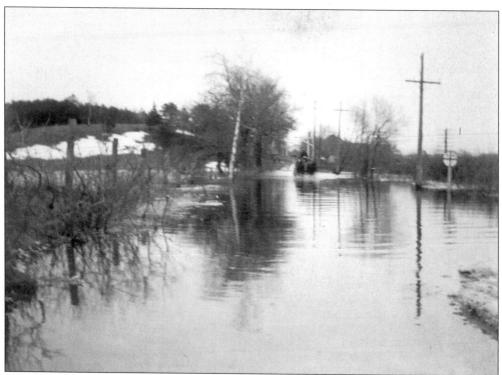

The Boston Post Road from Wayland Center to South Sudbury was often underwater. In 1921, an early thaw of deep snow created this flood. The long causeway contributed to the problem by acting as a dam. This photograph was taken just west of the railroad crossing. Bridle Point Hill is visible on the far left.

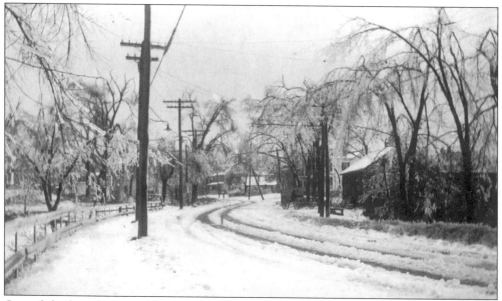

One of the best-documented ice storms in Wayland history occurred on January 21, 1921, leaving a trail of destruction throughout the town. This is a street scene in Cochituate. The weight of the ice tore down the overhead trolley wires, and they were never replaced.

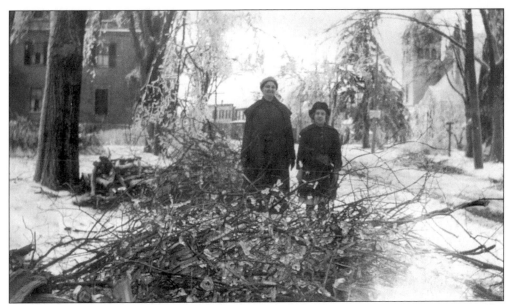

This view down Main Street in Cochituate shows the debris piled up on the street. The Methodist church is visible at the far right, and a glimpse of some Main Street stores can be seen over the man's shoulder.

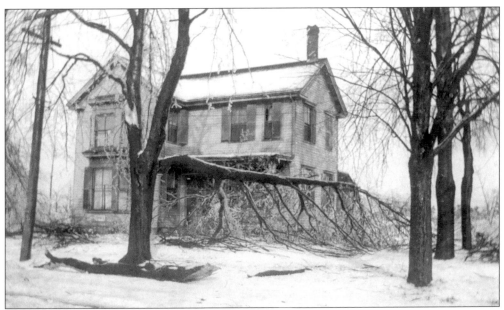

In this photograph of a side street in Cochituate, the principal branch of a tree has narrowly missed a house.

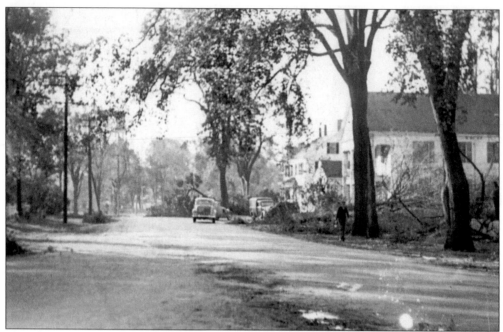

The September 23, 1938 hurricane was the single most destructive natural event in Wayland's history. Several of the large elms that arched over Cochituate Road were torn from the ground and fell across streets and adjacent buildings. Tens of thousands of other trees throughout the town were similarly damaged or destroyed.

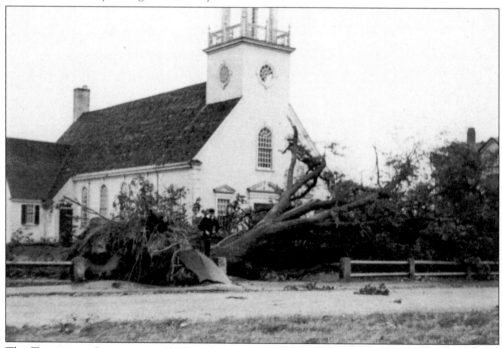

The Trinitarian Congregational Church lost a very large elm that grazed the church building and damaged the century-old rail fence with its granite posts. Nearly all of the downed trees pointed to the northwest, the direction toward which the winds were blowing.

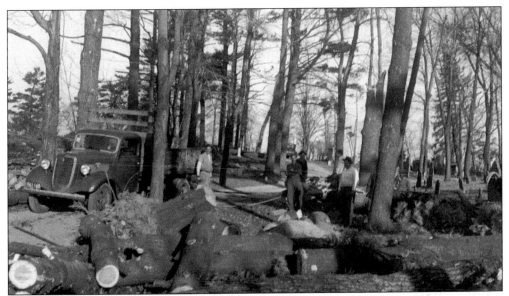

Wayland Tree Warden Charles Fullick and his crew spent many days in the North Cemetery, the one that suffered the most severe damage. Long rows of tall white pines surrounding the cemetery were flattened. Wherever possible, logs were taken to a portable sawmill on the Boston Post Road East and sawn into boards for later use.

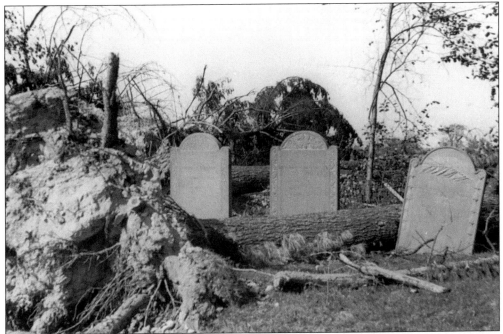

A 100-year-old white pine narrowly missed these gravestones. The mound at the left is the tree's root system. Many grave markers were not so lucky.

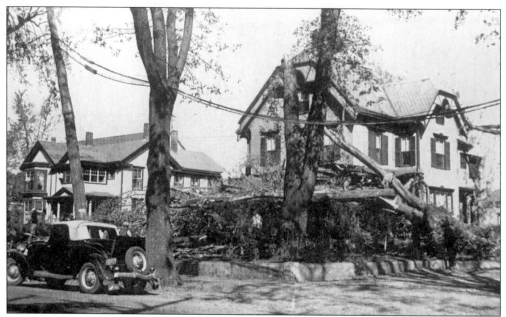

Gerald S. Baker took this photograph the morning after the storm on Main Street in Cochituate, close to St. Zepherin's Church. The house, built in 1874 by Charles W. Dean, an important shoe factory owner, was judged beyond repair and was demolished.

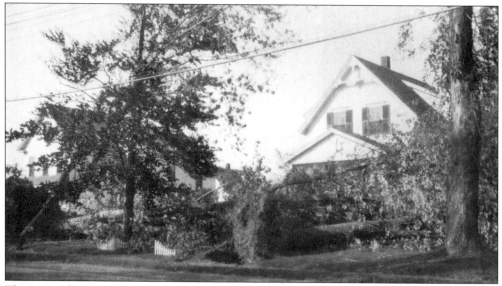

This scene shows more hurricane damage on a Cochituate side street.

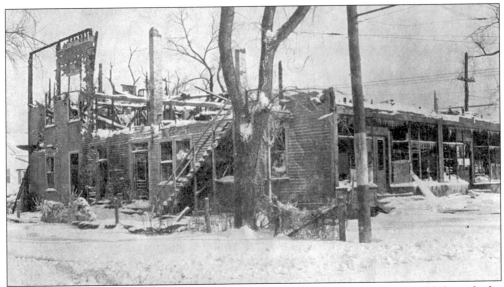

One of Cochituate's greatest fires occurred in January 1925, when flames ripped through the former Knights of Labor Hall, later occupied by the Cochituate Grange. At the time, the building was still occupied by several stores and the newly formed American Legion Post.

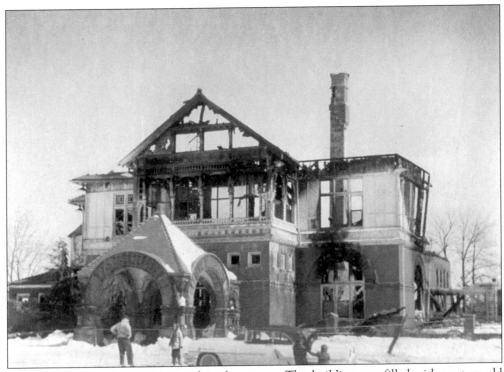

The Mansion Inn fire also occurred in the winter. The building was filled with century-old wood, and the blaze brought fire equipment from many neighboring towns. During the removal of the debris, an extraordinary collection of Native American artifacts was uncovered in the soil. The site was later developed into a large residential subdivision.

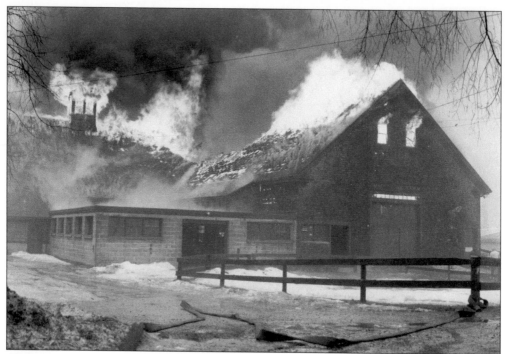

The Mainstone Farm barns, a famous Wayland landmark on the Hamlen estate at the corner of Rice Road and Old Connecticut Path, provided another spectacular fire. The cluster of barns had housed William Powell Perkins's herd of Guernsey cows for nearly a century. The barns were never rebuilt.

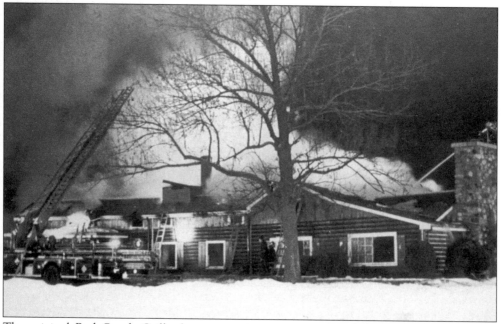

The original Red Coach Grille, born as an ice-cream stand and developed into a famous Boston-area restaurant, burned down in January 1976.

*Ten*

# RESTING IN PEACE

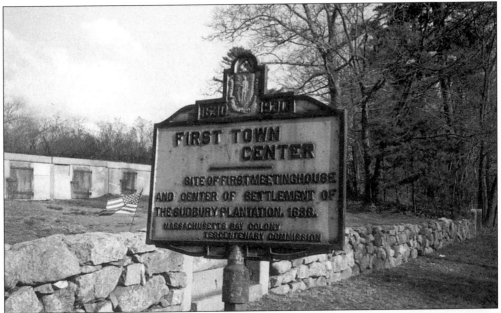

A Massachusetts tercentenary year sign in front of the North Cemetery on Old Sudbury Road reads, "Site of the First Meetinghouse and Center of Settlement of the Sudbury Plantation. 1638." The row of burial chambers in the background was built in the early 1800s for such worthies as Samuel Russell and Luther Sherman.

This inconspicuous marker, indicating where the first meetinghouse was built in 1642 by John Rutter, stands about 100 feet back from the road on a small level area. Rutter was paid 6 pounds (half in money). It is thought that many of the earliest settlers were buried without markers in the immediate vicinity of the meetinghouse.

One of the town's earliest gravestones lies nearby. It reads, "Here lyeth the body of Joseph Goodenow who dyed ye 30 of May: 1676: Aged 31 yers." Goodenow was the son of Capt. Edmund and Anne Goodenow, who lie nearby under similar granite stones, about 6 feet long and 2 feet wide.

This slate headstone marks the grave of Peter Jenison, descendant of Capt. William Jennison (who was granted land in southeast Wayland in 1638 for duties performed during the Pequot War—the different spellings of their last names was not uncommon). The stone is a beautifully preserved example of the winged skull, or death's-head, style popular at that time.

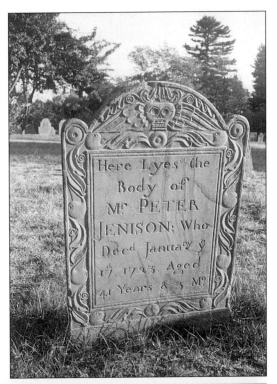

These are stones related to the Damon family. Isaac Damon, a veteran of the Revolutionary War, died in 1829 at the age of 91. He marched to the Concord fight under Capt. Joseph Smith's command. By this time, the popular motif was a weeping willow with an urn or other monument. The side margins are now columns rather than leaves and vines.

This is the gravestone of "Flora, a coloured woman," who died at the age of 94. Her stone is aligned in a north–south orientation, unlike all the other stones in this section of the cemetery, which are oriented east–west.

This is the gravestone of "Peter Booz, a coloured man," who died at the age of 68. His stone, like Flora's, is aligned in a north–south orientation. Both gravestones are adorned with the weeping willow motif and are near the graves of the descendants of Peter Noyes, an original settler of Sudbury.

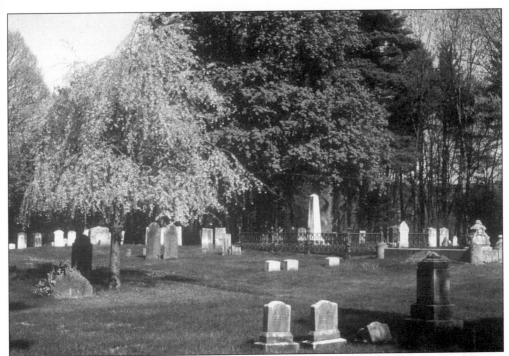

The South Cemetery, on Cochituate Road in Wayland Center, was laid out in 1835 to serve the two churches nearby. The gravestones are almost all of white marble, universally popular during the 19th century. There are also several burial vaults. A hearse house (actually a very small shelter for a hearse) sat in one corner of the cemetery.

St. Zepherin's Church purchased land on Bent Avenue in the late 1800s to lay out an attractive cemetery for its parishioners. At that time, nearly all the church members were French-speaking immigrants from Quebec. Angelic Tetreault, Lucien Tetreault's wife, is remembered as *son épouse*.

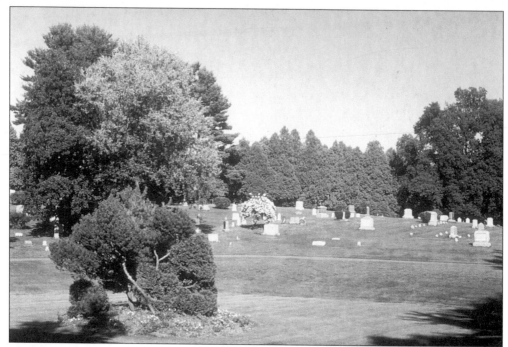

Land for Lakeview Cemetery, adjacent to Lake Cochituate, was purchased in 1871. The cemetery is laid out around a spectacular amphitheater, an arrangement that provides an awe-inspiring setting for Wayland's Memorial Day exercises.

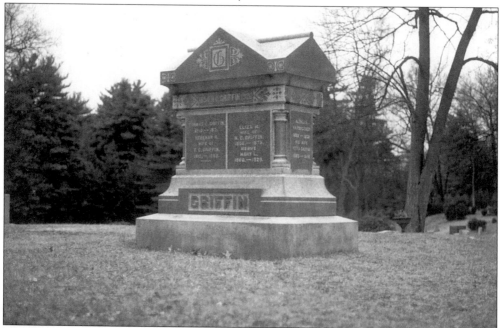

The Noble C. Griffin family monument is characteristic of the late 19th century, when white marble was abandoned for granite. Griffin was a prominent shoe manufacturer during the 1890s. His principal factory was adjacent to the 1873 school on Main Street, and his residence was next to Lakeview Cemetery, at 92 Commonwealth Road.